The First Eighty Years

A Story of Testing, Tragedy, and Triumph

VIRGINIA GODDIN DAVIS

Printed in the United States of America

06 05 04 03 02 1 2 3 4 5

Library of Congress Catalog Card Number: 2002108933

ISBN: 1-57736-272-1

Cover design by Gary Bozeman

All Scripture references are from the HOLY BIBLE, King James Version.

Providence House Publishers
PROVIDENCE PUBLISHING CORPORATION
238 Seaboard Lane • Franklin, Tennessee 37067
800-321-5692
www.providencepubcorp.com

To my late parents,
Alfred Lee and Mamie Creech Tippett,
for what they instilled in me as a child.

෯ඁ

And to my late grandmother,
"*Mammy*" *Siddie Parish Creech,*
for making me realize I needed the Lord
and His forgiveness.

෯ඁ

Many of my parents' grandchildren
and even great-grandchildren
are today involved in the Lord's work,
serving Him in preaching, music ministry,
and missionary efforts.
What a tribute to my parents
who had so much influence
in forming the lives of their offspring.

Contents

Preface

Whether you are a young boy or girl or an older man or woman, I believe that when you read this book you will find encouragement. If you don't know God in a personal way as I do, it is my prayer that you will have the desire to learn about Him and His love.

As a young girl I had a desire to be a missionary, mainly because I wanted my life to have a purpose. Even though I never made it to the mission field, I have always had a desire to be used by God and I have always loved people. However, I asked myself, "Who am I that He would ask me to do anything, knowing that there are millions more qualified than I?"

Reverend F. Wilson Bowman, who was at Bethany Baptist Church in Portsmouth, Virginia, in the 1960s and 1970s, was one of the greatest men I have ever had the privilege of calling "my pastor." He issued a great challenge to his congregation one Sunday morning about winning lost souls to the Lord. It was after that challenge—that very afternoon—that God inspired me with the poem that follows which expresses my compassion for all people.

Reading about my life's experiences will show you the way that God has carried me through it all. He can do the same for you. It is proof of His love for us. If this encourages and helps you, then, like the hymn by Ester Kerr Rusthoi, "It Will be Worth It All When We See Jesus."

New Life in Christ

Lord, help me as a Christian
To be worthy of Your name
Help me, Lord, to so love You
That I may tell others you came.

How You died upon that cross
To pay the penalty for our sin
How, now, we have a "New Life"
If only we ask You in.

Lord, help me with great boldness
To tell the world I meet
That You stand ready to forgive
If they but fall at Your feet.

Yes, Lord, help me to tell others
Their burdens You will share
Not because they are worthy
But because You love and care.

Lord with Your help as a Christian
I will walk hand in hand
With the Holy Spirit as my guide
I'll tell others of Your plan.

Millions lost we seek to win
I pray, Lord, my chance to give
Your plan of salvation, so
A "New Life" they, too, may live!

Acknowledgments

I thank all the people who have encouraged me to write about my life. I especially thank my many clients whose hair I dressed during my forty years of hairdressing. I tried to encourage them in different times as they often did me. My greatest desire was that God would use my experiences to help others. I wanted so much to know that each of my clients would meet me in heaven, and I tried to tell them how they could do that.

I also thank my children—Verna, Waylan, and Charles—for all they have done to encourage and help me. They are three wonderful people as are their spouses, who will all be with me in heaven one day.

Finally, I want to thank my dear Christian friend Frances Pope for lending me her proofreading and editing expertise in completing this work.

God Molds a Little Girl

LIFE IN THE COUNTRY

I was born on November 18, 1921, on a farm near Zebulon, North Carolina. My parents were monetarily poor but rich in so many other ways. They were Alfred and Mamie Tippett, insignificant to the world but well-known and loved by so many where they lived. They were kind and generous, loaded with much wisdom, and they did their best to impart it to their children. Later on in life, their wisdom and the lessons that I learned as a child would help me through some very difficult times.

There were six children in our family. There were three older brothers Elbert, Guy, and Douglas. Then there were two girls Virginia (me) and Helen. Finally, came our "baby" brother, Lloyd. We all grew up during the depression years of the 1920s and '30s. Times were tough and money was scarce. But we were not alone in having very little. Most people were in the same sad condition that we were. Children in those days were taught to work hard at a very early age. I well remember Mama making me a "cotton picking bag" out of a ten-pound cloth sugar bag so I could learn to pick cotton. I was a little one at the time, probably around six years of age. Our flour and sugar were

Virginia at age four.

purchased in cloth bags because the use of plastic bags for such things had not yet been discovered. Mama and Papa were teaching us how to work and to have responsibility before we were really old enough to understand the concepts of "working" and "earning a living."

My father and mother were godly parents and always took us to church; we were never sent. If any of us were inclined to use the excuse of "not feeling well" in order to stay home, we were not allowed to go anywhere else on Sunday. It was considered a sacred day. We did no work on that day and we were together as a family doing family things. Playing hooky from church was one thing that was not tolerated in our family. There were certain things that were drilled into our little heads. First, we were taught to never lie (especially about being too sick to go to church) and second, to never steal anything.

We were taught the Ten Commandments to help us know the difference between right and wrong, which formed our value systems that would guide us through life. Good morals and patriotism were emphasized heavily. This was not only taught to us by our parents and our church, but our schools also played a vital role in forming those strong values. Bible scripture memorization, such as Psalm 1, Psalm 23, and Psalm 100, was done right there in the public school.

Once a year we had what was called a "Revival" in our little church. An evangelist would come and he would preach every night for one week. It was during one such time that my maternal grandmother, Mammy, came to my seat during the altar call and talked to me about my salvation. She wanted to know that one day, when I died, I would be with her in heaven. She explained to me that because of Adam and Eve's sin in the Garden of Eden, sin was passed on to all the generations that followed them, including myself. I had inherited their sins and without forgiveness I would be forever lost. What an awful fate. But there was

good news—I could change all that and be forgiven of the sin that condemned me. She wanted me to invite Jesus into my heart and ask for His forgiveness. This would give me eternal life. I still remember Rev. Stancil receiving me at the front of that little church at an old-fashioned altar and forever changing my life. I was a new creature!

My parents would always invite the ministers into our home for a meal and fellowship with our family. They knew this would help us get to know the minister better and hopefully their stories would inspire us and their good example would rub off on us kids. Maybe this had a good effect on us. None of the children ever ended up in any serious trouble or ever found themselves in a jail cell!

Along with having our ministers into our home, Papa and Mama also brought our school teachers and even our principals into our home for a meal every now and then. My parents felt this was beneficial for everyone in that the teachers and principals knew our family personally and were assured that they had the full support of our parents when it came to discipline. We knew that if we got into trouble at school, not only would we have to deal with the punishment administered there, but there would also be more punishment waiting for us at home. Believe me, we received more than a lecture from our parents. Time out or sitting in the corner was not even considered an option. We had to go out and cut our own switches from the peach tree for our whipping. One thing was certain, we learned to behave ourselves!

How things have changed! We were never abused, but in today's society parents can serve prison time for spanking their own children. It's all about balance and knowing the difference between good discipline and abuse. Laws are in place to protect our children from abuse, and I do appreciate that. Society could have benefited from these laws back in my younger days.

When I was in the second grade I had a teacher who really believed in heavy discipline, which I know now was actually abuse. She was a small, skinny woman in her twenties. She had short, straight hair, curled toward her face in a rather boyish style. She rarely smiled, and she was very militaristic in her demeanor. If you, as her student, were called upon to spell aloud one of the words from our lessons and misspelled it, she would come to you and slap your face—first with the palm of her hand and then with the back side of her hand on your opposite cheek. Sometimes she took several children to the front of the class and spanked them with a paddle. This was rarely for misbehaving,

since we were too frightened to do anything wrong in her presence. Rather, it was all over academics and failing to "give the right answer." We were afraid to go to school, but afraid to lie about being sick or to play hooky from school. We were in an awful predicament. I remember being so paralyzed in my fear of this woman that I wouldn't even tell my parents what was going on. I was afraid that if I told about being slapped at school that my parents would misinterpret that and think I had misbehaved, and I would get another spanking. I just kept it to myself. Many years later a little boy finally told his mother what was happening. This mother was afraid of no one and promptly alerted the proper authorities and the teacher was removed from her job. I don't recall if there was any disciplinary action taken against her, but I learned that a few years later she was in a horrific car crash and was paralyzed from the waist down; as a child, I wondered if she were being punished for being so mean.

Papa and Mama always encouraged us in our studies. Good grades were a must. Even though I'm sure they needed our help many times, my parents would never think about keeping one of us out of school to work on the farm. But when we arrived home, our work was laid out for us. We worked diligently until nightfall when we stopped for a meal and then did our homework. The days were long and we didn't complain about having to go to bed. We were ready to hit the sheets. Of course, there was no television to distract us.

The fact that we didn't have much money never bothered us because no other family had much either. Papa became a self-taught barber and cut all of his kids' hair as well as that of many people in the nearby community. A license wasn't required back then and he would charge fifteen to twenty cents per customer. The hairstyle I am wearing today, at eighty years of age, was one that Papa had given me as a young child, even though I have had many different hairstyles in the course of my life. His creative ability was well ahead of his time.

Papa also learned to sharpen "cross-cut" saws for the community. This was the only type of saw that people had for cutting their heating and cooking wood for the entire winter. This work, together with the barbering, gave him extra money to spend on us. He had something special within himself that drove him to provide for his family in spite of the poor economy. This drive was evident in that we had several things other people didn't have. Although we were poor, Papa had his own car. This was a rarity. Ordinary people back then just didn't have cars. But because of Papa's determination, we always had one. One of

Virginia's Zebulon home.

the first cars I can remember him owning was an old Chevrolet that had no window glass but had curtains all around it that snapped on. We felt so special to be able to crawl into a car to go places when most people had to walk or ride wagons and buggies.

We also had one of the first radios anywhere around. It was a square box with a separate speaker on a stand beside it. I can remember listening to a Max Schmeling boxing match; people would come to our house from miles around because we had access to such things. Sometimes there were so many people gathering that Papa would take the radio out on the front porch so they could draw together in the yard and enjoy it. He was so kind and generous and people loved him dearly.

A camera and a hand-cranked Victrola were other things we had—long before they became commonplace. Papa and Mama bought records for the family to enjoy, and music rapidly became a very important part of our lives. Papa would also sit around at night by the fireplace and strum his old guitar and sing to his children. How he loved the songs of the church and singing about his faith in Jesus. He wanted so much to pass this love and appreciation of music on to his children.

Papa thought that my sister, Helen, and I should learn to play the piano. He bought us an old secondhand upright piano and then he proceeded to find us a music teacher. She had to travel a distance of about twelve miles to our home to give us our piano lessons in a room heated only by a fireplace. In the winter months, our fingers would get so cold hitting those old ivory keys that it was difficult to learn. We were more concerned about warming up than learning our notes!

Through those efforts, God gave me enough knowledge of music to be able to play for our little church when I was sixteen years of age, and throughout my life I have had the privilege of sitting down and playing my energies and my emotions out on the keyboard. Papa may have never realized what a great investment he made in my life with those fifty-cent music lessons. Then again, maybe he did. As he grew older and his love for music increased, he would listen to us play the piano and sing and he would always be moved to tears.

I will always believe that children should be afforded the opportunity to learn some type of musical instrument. It is such a wonderful outlet for one's emotions. You can tell what a person's mood is by the way they play their instrument, if they are truly connected to it. Whether they are happy, sad, excited, or mad, you can usually tell what they are feeling. As the years of my life passed along, I saw the important role music played in my life.

Christian Parents' Love

MY UPBRINGING

When I was about ten years old, Mama began teaching me to cook. I will never forget the first biscuits I made. They were not very good because they were rather hard. The texture was similar to that of a leftover biscuit sitting out on the table for about a week. My older brothers must have been awfully hungry, however, because they ate them all and began fussing at me because I didn't cook enough of them.

Being a young girl and having my first real experience at cooking a meal, or any part of a meal, was intimidating from the beginning. I was rather upset at the boys for complaining, and my response to them was not crying. No, crying was for sissies! My weapon of choice was my mouth. So, with my hands on my little hips and my head cocked to one side, I immediately retorted, "Well, if you're going to complain so much, I wish I hadn't cooked anything!"

Well, Papa just didn't care for women with an attitude and he wasn't about to let some little female upstart under his own roof talk this way to the hardworking males. He let me know right away that my attitude was not going to be tolerated. Although it may have been for

sissies, I cried when Papa fussed at me. The man could evoke fear in
you with any sound of displeasure in his voice. You sat up and took
notice with respect when he entered into the conflict.

We had plenty of food, but the variety of things to eat was very
limited. Mama did her best with what she had and we didn't go
without. We always had two cows, so there was plenty of milk and
butter. We learned to churn by the time we were able to grab the stick.
Chickens were very plentiful on the farm and they provided us with
both meat and eggs. Our hogs were butchered once a year and we
cured most of our own meat and canned the rest.

Papa had his cousin build us an icebox. The box was wooden on
the outside and galvanized tin on the inside. Sawdust was inserted
between the wood and the tin in order to insulate the box. This kept
the ice from melting so fast. The iceman would bring a five-foot
block of ice to put in the box and it would usually last about a week.
The decision to get an icebox was made as a result of an accident on
the farm. My parents had a very deep well and it gave us good cold
water. Neighbors and family who lived close by regularly came to

Mamie, Papa, Helen, Elbert, Doug, Lloyd, and Virginia.

draw water from our well. Because we had no way to keep our milk fresh, it was stored in a cooler and lowered into the well by a rope. There was an old woman who worked on our farm whom we lovingly called "Aunt Frances." Once, when she came by to get water, she lowered the bucket down into the water, knocked over the cooler full of milk and, you guessed it, she gave us a well full of milky water! It all was eventually cleared up but it took a long time of emptying a well of water by drawing out one bucket at a time. After that mishap, Papa decided that life would be easier if we had an icebox. Our icebox allowed us to make many

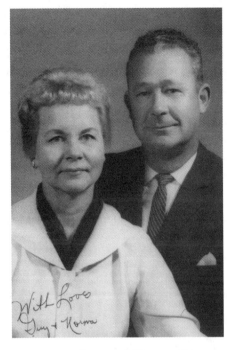

Guy and Norma Tippett.

freezers of ice cream with a hand-turned freezer, since we had plenty of milk. That was great since we didn't get many of the extras that children get today.

Papa planted fruit and nut trees throughout the farm. From June until late fall we always had some variety of apples. We also had different types of grape vines, including scuppernong and concord. There were cherry, pear, peach, pecan, and black walnut trees. We grew peanuts and popcorn to have extra goodies in the winter. Each spring and summer we had a garden of many kinds of vegetables and Mama would always can as many as she could to last us through the winter. I had a job in helping with preparing corn, butter beans, and tomatoes. We also canned meats, especially sausages, and it tasted like fresh meat. We had to can our food because we had no electricity and therefore we had no freezer.

Having no electricity also meant having no electric lamps for night reading, but Papa always wanted the best for our learning. As soon as he found out about a wonderful tool called the Aladdin Lamp, he bought us three of them. Boy, were they nice and bright! They were almost as good as having electric lamps. Papa never graduated from

high school, so he was determined that his six children would all get a high school diploma. Education was so important to him and he knew that it would be the key to a successful future for all of us. He would do any small thing to encourage us to pursue this, even buying something as small as good lighting by which to study.

3

Generation Influence

MUH AND MAMMY'S LOVE

Our parents set a fine example for us in the way they regarded their own parents. They were so kind and loving to their own aging parents and we were taught to show them equal respect. Papa's mother was Elizabeth Wilder Tippett, whom we called "Muh." She had suffered a stroke when I was very young and since my grandfather was already deceased, Muh's children would care for her by keeping her in their own homes for two-to-three-week intervals. At the end of each period, the next child in line would come and pick her up and take her home with them. In those days we didn't have nursing homes so we were taught to take care of our loved ones in our own homes. Even as a young child, I learned to help take care of my grandmother. During her times with us, I learned to perform many of the duties you see in the modern-day nursing homes, only with much more love and compassion because she was family.

Caring for Muh was not just a responsibility for Papa. Mama was also very kind to Muh. She didn't look at her as the old mother-in-law and didn't resent her presence in our home. This was the mother of the man my own mother fell in love with and whose soul mate she

11

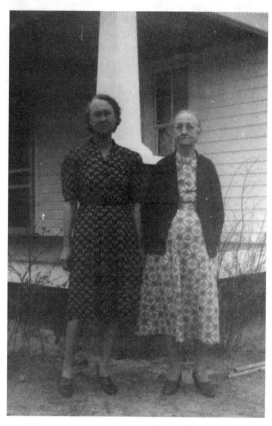

Mamie and Mammy.

became. How could she not love the woman who had given him birth and raised him to be the giant of a man that he was? She gladly waited on Muh hand and foot and trained her children to treat Muh with the respect she was due. There was never a cross word between Mama and Muh. Mama would dress her up to make her presentable, doting over her in every way, knowing that it meant so much to Muh to look nice. Mama made her pretty bonnets and aprons to wear and made her feel like she was a part of all that was going on in our busy home.

Sometimes I look back and think how nice it would be to be able to go back to that time and do more for Muh—to make her more comfortable and improve the quality of her life. I didn't realize until I was older that this woman was much like an angel that God had loaned to us young children. I remember how she never complained about anything but always gave us a gentle smile, even if we hesitated to obey her at the moment. Many years after Muh's death, I learned that as a young lady she helped start a church. What a wonderful

legacy to leave behind. I would love to know that my grandchildren would someday revere my life as I remember Muh Tippett.

Mama's mother, Mammy Creech, lived nearby and we saw her regularly. I loved to go to her house because she was the best cook— even better than Mama. She always had plenty to eat and if she knew we were coming, she would fix something extra special in honor of the visit. She had orchards and every imaginable kind of fruit growing in them. Her house was always full of the smell of freshly baked pies and country biscuits. She was a quiet, soft-spoken woman, much like my own Mama. She loved Jesus and served Him with her life and was the perfect example of what a grandma should be. As I mentioned previously, she was the one person to whom I give the credit for leading me to the Lord. The grandchildren were precious to her and she would welcome us into her home with open arms. It was a real treat to get off of the school bus at her house so I could spend the night with her. My growing years were filled with wonderful memories of my grandmothers.

As I grew, I saw that life was not without its disasters. During my junior year of high school, Papa had gained employment in a tobacco warehouse about twenty miles from our home. One day he was in a terrible automobile accident while riding with his boss. Apparently he lost control of the car in a sharp curve and the car went off the road and flipped over completely. Papa was found inside the car in a twisted fashion between the front and back seats with his back broken. Papa was taken to the nearby hospital and someone delivered the news to us that he was in serious condition. One of Mama's brothers took us to the hospital to be with Papa. He was unconscious and the sight of him weak and helpless was frightening. Papa was a big, strong man, well over six feet tall and a head taller than most people. He was never sick a day in his life that I could remember. Yet, there he lay—pale, helpless, and vulnerable. It was almost more than I could bear to see. In those days, a broken back was a grave condition. He was placed in a bed and wedged between sandbags. For a long time we didn't think he could possibly live. Even his nurses and doctors gave him a slim chance of pulling through the situation. Papa remembered after his recuperation that he had heard his nurses talking upon his arrival to the hospital saying, "Well, here's one that won't be here in the morning!" Even though he was unconscious, his ears were still listening.

Much prayer went up in Papa's behalf. He was in the hospital for more than sixty days. We didn't realize until then how much we

depended on him and how he took care of everything. My brother Doug was driving our old Chevrolet that we used to go back and forth to the hospital. He, being young and inexperienced, didn't realize that a car needed oil, as well as gas to run. Consequently, the engine burned up and we no longer had a car. Then we had to rely on others to take us to visit Papa.

Papa did heal well enough to come home, but he was unable to work for a long time and it resulted in a very lean year on the farm. What made things worse was that a representative of the insurance company came to see him and encouraged him to sign a release statement that offered to pay for his hospital bill and nothing else. Papa was easy-going and trusting of people, so he signed away his rights to compensation for lost income. He had no idea that he would never be the same, even though his condition would improve somewhat. Eventually, he was confined to a wheelchair as he aged.

Papa's recovery was very slow. He had been working on the tobacco market weighing tobacco for the warehouse, but he could no longer do that due to his condition. We still had the farm and we all worked in it while Papa recuperated, but during that same year one of our best mules died. In those days a farmer's mule was the only tractor that he had to till the farmland. With the best mule being gone and unsupervised children in charge, we did not have a very good crop for market that year. Our total income for the year only amounted to about four hundred dollars. Naturally, there was no money for another mule and no money for a new car.

We lived by faith during those days. Family, as well as neighbors, always came to the rescue of another family. We were taught the Golden Rule, to "Do unto others as you would have them do unto you." It was a common practice to gather together and go to a neighbor's farm and work it if there was serious illness in their family. This is what we depended on. We did not go hungry and always had a roof over our heads. Everyone pulled together and rallied around us. If we needed rain for crops, we would ask the community to gather at the church and pray for it to rain. God answered those prayers, so naturally I grew up knowing about God and His goodness. Knowing Him personally made a difference in my life.

4

Leaving the Nest

A YOUNG WOMAN FACES THE WORLD

After my graduation from high school I didn't have the opportunity to further my education, mainly because I was lacking funds and needed to go to work. Two of my three older brothers joined the Navy, while the third took a job in the city. Suddenly I found myself the oldest of the children living at home. One weekend my brother Guy visited from the city and asked me to go back with him to find a job. I was so excited to go and had no trouble finding work. It was during this time that Japan bombed Pearl Harbor and for me, as well as the rest of America, things would be forever changed. Since the armed forces took so many of our men, it was left up to women, such as myself, to take on jobs that were traditionally held by men.

I met and dated quite a few very nice young men. Most of them were servicemen because I lived in Greensboro, North Carolina, an Army town at that time. But not all of the men serving in our armed forces were of the best character. I was just a young girl from the country and very naïve to the fact that there were bad people in the world who would take advantage of me. The phrase "date rape" was only coined in recent years; however, I learned its meaning long before

Virginia at age eighteen.

it was named. It became a reality for me. A friend in my boarding-house introduced me to the most handsome young man you could imagine. Our first date was wonderful and he seemed to be all a young woman like me could ask for. He was tall, dark, and hand-some. The second date was great as well, until he took me home and we parked in front of the boarding-house. Suddenly, this huge guy grabbed my arms and put them behind my back, and he held me there with his weight against me. I was petrified, and as he held me down, he started tearing at my clothes, unzipped his pants, and prepared to do the unthinkable. I started praying to God to help me, to show me an escape from this madness. With my hands and feet completely immobile, my choices for defense were greatly limited. As he leaned in toward my mouth to kiss me, God gave me the idea for my escape. As soon as he was close enough, I opened my mouth and sunk every tooth I could into the man's chin! I bit him for all that this country girl was worth. He tried to pull away from me, but I went up with him because I was hanging on to that chin like a tiger! I don't think he knew what was happening. I grabbed the door handle and rolled out of the car before he had a chance to know what hit him.

The next morning, I told my friend that the "nice man" she intro-duced me to had attacked me. She worked in the Provost Marshall's office on his base, so she called him into her office to confront him with the incident. She reported back to me that she knew I was telling the truth as I had left a perfect set of tooth prints all encircling his chin! She threatened to have him court-martialed for his actions. I didn't pursue it, mainly because of my youth and inexperience and also I feared ever having to lay eyes (or teeth) on him again. That was another miracle that God performed in my life, but there would be many more to follow.

While still living in the boardinghouse, a frightening thing happened one night around midnight. The landlady, Mrs. Rouf, was such a sweet person who always took care of us and tried to protect us, but her job became increasingly tough as she eventually had around thirty-six boarders. She always took every precaution and faithfully locked the doors at a certain time each night for our protection. But one particular night the front door was accidentally left unlocked. It could have been any one of the girls who had unlocked it when coming in late and failed to lock it back. It would be this one mistake that gave a burglar his chance to rob us.

I had been in bed asleep but awoke to go to the bathroom. I had just returned to bed when suddenly there appeared a shadow in the doorway. I first thought it was Mrs. Rouf's cousin who also lived at the boardinghouse and performed routine house maintenance. I wondered what he was doing in the doorway to my room at that hour and in the dark. Then I realized that this man was much smaller than Mrs. Rouf's cousin. By that time he was easing himself slowly and silently into my room.

I did not know if it was from fear or curiosity, but I allowed this burglar to slip by the end of my bed over to the table where I kept my purse. At that time I called out, "What in the world are you doing?" He came quickly to my bedside and when he did I grabbed him by his wrists and began to scream while he was telling me to "shhhh-shhhh!" Fortunately Mrs. Rouf heard me screaming, "There's a burglar in the house!" because her room was adjacent to mine. I can still hear her dialing that old-fashioned phone to summon the police to our rescue. The burglar wiggled free of my grip and ran down the hall as fast as his legs could carry his skinny body. But I put my legs to good use and was right on his heels. I ran out of the front door behind him and proceeded to

The boardinghouse gang.

chase him while still wearing my red and white striped Peter Pan pajamas! However, he was able to outrun me; I watched him run out of sight, hoping to be able to point the police in the direction of his departure. The police did arrive, but they were never able to find the man. Thankfully, they were kind and considerate to us and cruised by the house regularly for the rest of the night.

The next day my nerves were a little shaky from all of the previous evening's events, thinking how I could have been seriously injured or killed. I had been unusually bold and strong that night before, and I knew that my strength had come from the Lord and that He had protected me and kept me safe through it all.

5

Living in the Real World

MY FIRST LOVE

W orld War II was raging and I eventually went to work in the local Thom McAn shoe store. I began as the assistant store manager but because of the war's drain on the men in the workplace, I was quickly promoted to manager to replace a man who was called into the service. But this promotion made it necessary for me to travel to the coastal city of Wilmington, North Carolina, to work. I remember the transfer because I did it by bus and it was filled to over capacity, most of the riders being servicemen. In other words, we were packed in there like sardines! It was on July 3 and it was hotter than you can possibly imagine.

After settling down in a boardinghouse and making new friends, I was very happy. I really enjoyed living in Wilmington. I took advantage of the local beaches every chance I got. The boardinghouse was only about four blocks from my work, so naturally the walk was nice and convenient. On one such walk home from work, just a few weeks after arriving in this town, I noticed a big black car pulling along beside me with a couple of men in the front seat. They were trying to flirt with me, calling out, "Taxi, lady? Taxi, lady?" They really annoyed me

Virginia at age twenty-four.

because I thought their flirting was just too bold and they were coming too close to me with their car. You must realize, I was still just a young girl from the country and these big city ways struck me as being quite rude. When I arrived home, I complained about it to my landlady but she assured me they meant nothing by it.

A couple of months after my transfer, all was going quite well for me. A young lady working for me called me to the front of the store. It seemed that a customer had a complaint about his shoes. We always tried to please the customer, so I turned on my southern charm while remaining professional and business-like and asked him to explain his problem. He pointed at his worn-out looking shoes and said, "My shoes have not lasted as long as they should have!" When I asked him how long he had the shoes he replied, "Long enough to walk maybe 1,000 miles." I stood there with a look on my face that must have appeared to say, "You must be pulling my leg" or "I wonder what mental institution you escaped from."

It became quite comical to my coworker and she turned to me and said, "Meet Uncle Charlie!" She continued, "Charlie does not have a complaint, he just wants to meet you." I must have blushed, being very flattered, because standing there before me was the most hand-some and smooth-looking man I had ever seen. He was gorgeous and dashing with his hat tilted to one side above a beautiful set of hazel eyes. He reminded me of a real life Dick Tracy. My work went a little incomplete that day because Charlie lingered around long enough to insist that the two of us double date with him and his friend. My Mama didn't raise a dummy. I jumped right on that and said, "Yes!" After he left, my coworker returned to me and burst my bubble. She said, "Virginia, didn't you know he was just kidding? He's not planning on seeing you tonight!" I had never been so humiliated in my life to think that he had done this to me. That night after dinner at the boardinghouse, I decided to walk across the street to an open-air market to buy a Coke. While standing there someone approached me from behind and said, "Why did you leave me?" I turned around and there stood Charlie and my heart went flip-flop! My coworker wasn't as smart as she thought, because Charlie had every intention of taking me out that night. He wasn't kidding around after all.

The date went very well even though we didn't do anything special. We only went to a drive-in theatre and did more talking than watching the movie. He did one thing that shocked me—he removed his hat in the car and uncovered the prettiest baldhead I'd ever seen.

Charlie shocks Virginia by removing his hat.

At twenty-three years of age, I had expected my boyfriend to have a full head of hair and not to be bald like my Papa! Back at home, I told some of the girls that it was the best time of doing nothing I had had since arriving in Wilmington. I even overcame the shock of his unveiling his polished crown to me.

We dated often, but on one occasion I broke a date with him offering the excuse that I had to work. The real reason I broke the date was because an old boyfriend came into town and called and begged me to go out with him. Well, "be sure your sin will find you out" as the Bible says in Numbers 32:23. I never dreamed that Charlie thought enough of me already that he would go to the store to visit me at work. I had figured he would just sit at home that night and we'd go out another time.

The next morning Charlie was at the store, standing out front waiting for me to arrive to open up. He was ready to face me with my ugly little lie since he had not found me working the previous night as I had said. I felt so terrible for having lied to this nice man, knowing it was wrong in God's eyes. I had done the very thing that Papa and Mama had always cautioned me against. I had hurt my newfound friend. I told him how

sorry I was and that I would never ever lie to him again; he forgave me.

You see, Charlie had his eye on me from the moment I arrived in Wilmington. On my daily walks to and from work, I passed right by his courthouse office window. He was determined to meet me somehow. By the way, he was one of the two men flirting with me from that black car shortly after I arrived in Wilmington.

Charlie Snow and I fell deeply in love and after a few months, he asked me to marry him. I took him home to meet my family and they were all so impressed with his kindness and thoughtfulness of me. They all knew I had found a wonderful and considerate man. Only one year after that meeting in the shoe store, we were married in August 1945. We took a train down to Charleston, South Carolina, where my oldest brother, Elbert, was stationed in the Navy and said our vows in his little Baptist church. The only witnesses were Elbert, his wife Kathryn, and their son Bert. We didn't have much in the way of material things, but God gave us so much in other ways to make us happy.

6

The Big Apple

For our honeymoon, we traveled by train to New York City. It was my first time in the Big Apple but Charlie had been there many times on business, so he knew where to take me to see the things of interest. It was cold and rainy when we arrived. We went to our hotel, which seemed so elegant and sophisticated. It was such a romantic setting. Charlie took charge of everything regarding our transportation and our hotel, and I remember feeling excited and apprehensive yet at the same time a wonderful feeling of security. He was so confident and controlled.

Because the weather was cool and wet, he decided that we needed to do some shopping for clothes that would better suit our needs. It was awesome to see the magnitude of this great city with such tall buildings and so much traffic. We shopped at many of the famous stores of the time such as Macy's, Gimbel's, and Saks Fifth Avenue. We also visited the Statue of Liberty and viewed the city from the top of the Empire State Building.

It was at the Macy's store that Charlie seemed enthused about a particular piece of furniture. His knowledge of it, as well its potential impact on the world, impressed me so much. He told me,

"Before very long, all people will have one of these in their homes. This box will bring the news and many live programs right into our homes. Only, it will be different than just another radio program. We will be able to actually see things as they happen, all from this little box!" He told me that we would see the people as they talk to us over the airwaves and he said this was called "television." How exciting and overwhelming this was to me. Just the thought of being able to see what was going on in other parts of our country and in the world seemed so surreal. That was my first knowledge of television. I hadn't even read anything about such a device in the newspapers. At that time there were no television stations or networks to carry this into our homes but, just as Charlie had predicted, it soon became available to the American public and it certainly changed life as we knew it.

Charlie was so excited to take me into Chinatown where we ate dinner in a Chinese restaurant. I remember eating a piece of a very unusual fruitcake that was so delicious. Charlie was a wonderful chef in addition to his other great abilities and he carefully tasted the fruitcake, savoring every bite. He mentally picked out the different ingredients in it and when we returned home, he immediately went into the kitchen and copied the cake recipe to perfection. You could not tell the difference between what we ate in New York and what he prepared in our kitchen in Wilmington, North Carolina.

Charlie had a friend who, at the time, worked for the government and lived there in the city. He picked us up from our hotel and took us riding all around New York and even up to the outskirts of Harlem. He wouldn't go any further, however. At that time, we were led to believe that the racial tension was too strong in Harlem and that white people were not welcomed there. We actually feared that our lives would be in jeopardy if we chose to enter that part of town.

We visited the Melville Shoe Corporation Headquarters. This was the parent company of the Thom McAn shoe store that I managed. I still remember how grateful I felt to this company because not only were they so good to work for, but if they had not transferred me from Greensboro to Wilmington, I would never have met my wonderful husband who made my life so complete. I had such a great sense of pride and felt so honored to be able to tour the company's headquarters and see the inner workings of the business. It made my job seem more special and changed my everyday work life to something much more than the hum-drum existence people often find in their careers.

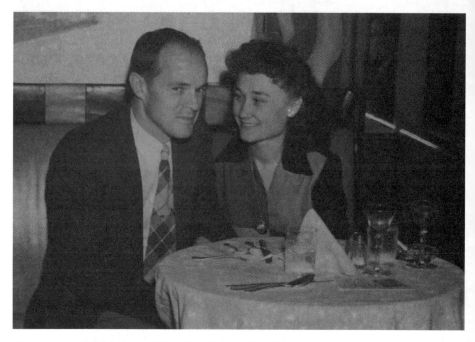

Virginia and Charlie in New York City for their honeymoon.

As I'm writing about my honeymoon in this great city, it is September 2001, and I just saw new images of the terrorists' attacks on the World Trade Center. It is so horrible for innocent people to be killed by some madmen. It makes me realize even more that there are so many people in the world who need to hear about the God that I serve and what He has done for me in troubled times. I keep hearing about the prayers being offered up on behalf of those who perished and for the families that were left behind. It is my prayer that people of all nations will come together and realize that our only hope lies within the comfort of God Almighty and His Son, Jesus Christ.

God Gives Me a Family

*C*harlie and I decided to start our family soon after we were married because I was already twenty-four years of age and Charlie was thirty-eight. I was nervous and anxious because, like most young women, I wondered if I would be able to conceive. Needless to say, we were so happy when we found that we were going to have our first child.

One day some friends of mine were taking a trip and were going to be near my parents' home. They invited me to ride along with them so I could spend some time with Papa and Mama. I was five months pregnant at the time and in very good health, so I didn't hesitate to accept their invitation. I never even thought to ask my doctor if he considered it safe for me to travel. It had been some time since I had seen my parents, so I was really looking forward to a wonderful visit.

After going to bed that night, I awoke with a stomachache. I remember thinking to myself, "I wish I hadn't eaten that banana before bedtime." Thinking it was just an upset stomach, I decided not to awaken Mama. The next morning, however, I was in such pain that Mama decided to call the doctor. He immediately came and examined me and reported to Mama, "She is having labor pains and if I can't

Virginia's Wilmington home.

stop them, she will deliver a premature baby today!" He gave me a
shot and my family called Charlie.

We were twenty-five miles from the nearest hospital so the
doctor said if the baby were born, it would be in the house, which
meant the baby most likely would not survive. The doctor felt that
taking the trip and failing to stop along the way for breaks had
caused this to happen.

Charlie arrived quickly. As a deputy sheriff, he probably used the
sirens and flashing lights on his county car to get to me, breaking the
speed limits all the way. When he arrived, he immediately came to me
in the bedroom where I had been resting. I fully awoke as he entered
and was comforted to see care and concern on his handsome face. I
don't think I had ever been as happy to see anyone as I was to see him
at that moment.

The drugs were performing as the doctor had hoped and by nightfall
the contractions stopped. Charlie felt comfortable enough by that point
to return home, and by the following morning all seemed perfectly
normal. I was so grateful to God for His mercy and protection of my
unborn child and me. I stayed at Mama's for about two more days and
headed back home, making sure I made routine stops along the way.

Our son was born almost one year after our marriage and what a joy he was for us. We named him Charles Alfred "Cal" Snow, for his dad and for my father, Alfred Tippett. He was beautiful and precious to us and was just as healthy as any baby could be, despite the fact that I had come so close to losing him just four months earlier.

Charlie just adored his newborn son. He doted over his little Charles like any new father would and probably more. He did everything you could do for a baby except nurse him. That was one job he couldn't take from me. Anywhere we went, the baby went with us and remained in his father's arms. It warmed my heart so much to see this wonderful man love his little son so much.

After the birth of our son, Charlie took a job with the state and we moved to Raleigh. Charlie's mother had been living with us since we were married and she traveled with us to Papa and Mama's one Christmas when little Charles was about two and a half years old. Suddenly, on Christmas Day, she became very ill and we decided to take her back to Raleigh where we put her into the hospital. Apparently she went into a diabetic coma that night and she died the very next day. That made Christmas such a sad time for all of us. It seemed that from that point in my life, Christmas became a time of reflection and always had a little cloud of sadness over it.

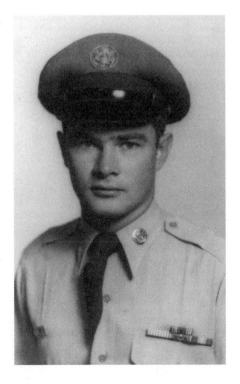

Frank Snow.

Charlie had a son, Frank, from his previous marriage. Frank lived with us until he was old enough to join the service. He was a fine young man, very much like his father, and he became special to me even though I was not his natural mother. When he joined the service, we worried for his safety because of war going on in so many places. God was so good and He protected Frank and brought him safely home. He

later married a very sweet young lady named Anne and they had three lovely children of their own.

Three years after the birth of our son, we were again blessed with a baby, a beautiful little daughter. We named her Verna Lee and she was the most beautiful baby I had ever seen. She looked like a little china doll, so perfect in every way. She had creamy white skin, blue eyes, and dark hair. Her little eyelashes were so long and pretty and they curled upward out of the corners of her eyes. People everywhere would remark about how beautiful she was. I felt so blessed to have a son and a daughter. My family was beautiful and complete. It seemed at times as though we were living a fairy tale. My husband, once again, didn't leave all the tasks of taking care of small children up to me. He took such good care of both of his children and defined the role of the perfect father. Everywhere Charlie and I went we would go as a family; we believed in taking our precious children with us.

8

My Faith Tested

Horrific Tribulations

*C*harlie and I had talked about having other children, but due to certain circumstances in our lives it never happened. We almost gave up on the idea because Charles and Verna were growing older as were Charlie and I.

I had experienced some medical difficulties and the doctor performed a D&C on me, and a short time afterward I found myself pregnant again even though I was not planning on this. When I was a few months into my pregnancy, I received word that my mother had been diagnosed with colon cancer and was facing surgery. It frightened me because, at that time, few people survived this kind of cancer, so I immediately made plans to go to her side during the operation. My father also needed me to be there because his health was poor and he was unable to walk very well.

Mama came through the surgery and the prognosis was good because the cancer was detected early. I decided that I would stay and care for her as long as I could. She didn't know that I was pregnant, and I didn't want to tell her because she would worry about my caring for her. The doctor had given her a colostomy and her recovery would

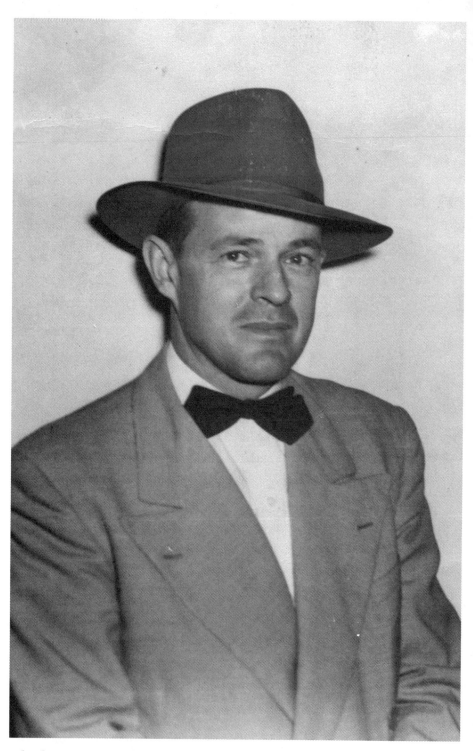

Charlie Snow in 1948.

be slow, but at least she was alive. Thank the Lord, He not only brought her through the surgery, but she would go on to live a great and productive life for thirty-four more years. She was never told that her surgery was for cancer.

After a little while at home with my mother, I had a call from Charlie saying that he needed me to come home because he was having some back problems. When I arrived home, I insisted that he see a doctor. He visited a chiropractor, who manipulated his spine with the hope of helping him by realigning his discs. He continued to be in pain afterward and it appeared that the visit had not accomplished anything.

About three months passed and I was about six months into my pregnancy. Charlie's back was still bothering him a great deal and he went again to the chiropractor to seek some relief. I noticed, however, when he returned home that he seemed to be hurting even more. The doctor told him to sit in a tub of very warm water and to take aspirin. After doing this, he decided he would try to attend a statewide Masonic Lodge meeting that had been planned for some time. He left for the meeting and I would not see him for several hours.

The doorbell rang late that evening and upon opening the door, I found two men, one on each side of my husband, supporting him. They brought him into the house and he was as white as a ghost, wringing wet as if he had fallen into a river. He was in so much pain that he was sweating profusely. I was terrified and could not imagine what could have happened to him. They took him in to his bed while telling me that they had tried to take him to a hospital, but he had refused because he was worried about me being home alone and six months pregnant.

We had a doctor living in our neighborhood who had once performed a simple surgery on Charlie, so I called him and he came right over. He told Charlie that he must go to the hospital immediately because he didn't know what could cause so much pain.

We had recently changed our health insurance coverage. After arriving at the hospital about 9:00 P.M., I found out that my new hospitalization coverage would not go into effect until midnight. Basically, I had no coverage because we were in a gap. Charlie had to be seen right then, however. He was in so much pain that he was screaming and I couldn't let the gap in coverage stop me from getting him proper help.

At the hospital they began trying to relieve him of his pain, but the doctors' efforts seemed futile. One doctor told me that they had

given him enough medicine for five men and still could not ease his pain. They needed to do X rays but could not do that until the pain had subsided somewhat. At this point, nothing was working and they were afraid to give him more medicine because it might paralyze his respiratory system. They were finally able to get a portable X-ray machine into his room to take some pictures of his back.

The X rays revealed that Charlie's back was broken. They measured him for a specially made back brace, but when they attempted to fit it they couldn't because of his excruciating pain. I sat helpless in a small waiting room down the hall and I could hear his screams all the way from the other end. No one could understand why Charlie was suffering so much. The doctors consulted with someone in Norfolk, Virginia, and made a decision to try a new Egyptian drug to see if it would alleviate his pain. It was supposed to keep him asleep for about seventy-two hours. It only lasted for four hours but it was long enough for the doctors to do some further X rays to discover his problem.

I was in the waiting room alone when they returned and told me that the diagnosis was multiple myeloma, which was cancer of the bone, and that there was no way he could live. The longest he could have would be six months. The doctor said the X rays showed that Charlie's bones appeared as though they were moth-eaten.

My world came tumbling down on me. There is no better way to describe it. Mama wasn't even well yet from her serious cancer surgery, I was six months pregnant, and then I was being told that my husband had terminal cancer. I began to ask God, "Lord, how could you let so many things happen to me all at once?"

Pregnant and alone, I had to drive back home. I remember needing my mother so desperately but she couldn't possibly come to my aid. I felt much like Job from the Bible must have felt. How much could I be expected to bear?

I started crying to God and asking Him to help me hold onto my faith. I knew I belonged to Him and that surely he would see me through these times. I felt like I was coming completely unraveled. In the days to follow, I walked about as if I was in a trance. I felt as though my life was over. How could this be happening to me? I had everything to be happy over—my wonderful husband, my two children and another child on the way, my home—everything had been so perfect and now it seemed as though it were cruelly being snatched away from me.

God's Plan

My Experience of Life and Death

*A*fter about a month in the hospital, Charlie was allowed to go home with me. There was nothing else they could do for him except to relieve his pain as much as possible. His orthopedic doctor told me that this type of cancer was probably the most painful of all cancers.

Upon leaving the hospital I found out I didn't owe anything. How could this be? I was fully expecting to be hit with a bill that would surely devastate us and possibly take everything that Charlie and I had spent our lives together accumulating. Remember, my insurance was not quite in force when I took Charlie to the hospital. It wasn't supposed to take effect until midnight of the evening that he was admitted. Yet, somehow God had provided for me in the first of many provisions with which He would bless me on this difficult journey I was traveling. Only God in heaven could perform such a miracle for me now.

My sister, Helen, flew from New York to assist me with the vast amount of decisions I had to make and to provide as much support for me as any dear sister could. After staying by my side for a few weeks, she headed back to New York and took my seven-year-old daughter with her. She would enroll Verna Lee in school there on Long Island,

which would relieve me of some responsibility and let me focus on the tasks at hand. My ten-year-old, Charles, would stay there at home because he required less attention and could be of some help to me.

The next three months I was very busy caring for Charlie because he was completely confined to the bed while, at the same time, I was caring for myself in preparation for the birth of our next child. It was a bittersweet time because even though I was slowly losing my husband, I was also looking forward to the birth of this precious baby that I hadn't even planned on having. I concentrated on the fact that God had given me this little life to nurture and that somehow he or she would bring some happiness and purpose to my life at a time when I was losing so much.

The months eventually passed and it was time for the arrival of our baby. It was close to midnight on December 19, 1956, when I realized the time had finally come. I had already planned for a couple of my neighbors to assist me when I went into labor. My next-door neighbor to my left would take me to the hospital while the neighbor on the right would come in and sit with my husband and Charles. The neighbors would then get together and have Charlie admitted back into the hospital for the duration of my stay because he needed someone to care for him around the clock. Charles would then stay with a friend in the neighborhood until I returned home.

My neighbor came right away to take me to the hospital. It must have been a difficult task for the poor man to awaken and take a mother in labor to the hospital because he had never had any children of his own and was not sure what to expect. He just gripped the steering wheel and hardly spoke the whole trip. The other neighbor was detained for a while so we left Charlie alone with Charles. Charlie was unable to get out of his bed and was afraid of being left unattended, so he told Charles that if he would sit up with him and stay awake, he would tell him where his Christmas present was so that he could open it early. That probably was the only way he felt he could encourage a young boy to sit up all night.

At about 2:00 A.M. on December 20, Claude Bartley Snow was born. Around 8:00 A.M. that morning I staggered over to a phone on the wall to call home. I needed to find out if my husband had been admitted to the hospital yet. A nurse found me as I was tearfully trying to dial the phone, but having been sedated earlier I couldn't even read the numbers. She kindly promised me she would find out about my husband if I would return to bed. A short time later that same nurse

came into my room with a wheelchair. Without telling me of her plans, she put me into the chair and rolled me down to the nursery. There she picked up my sweet little angel son and placed him in my arms and we proceeded down the hall.

A few moments later we entered a ward of the hospital where my husband was being cared for. She took our baby and placed him beside his precious father. Never again would I experience the feeling that overwhelmed me at that moment in time. There lay on the bed two lives that I loved so much—one who had just arrived in this world and the other who was soon departing from it. It touched all those that were around to see what was happening. Never had they taken such a young baby, just seven hours old, out of the nursery and carried him across the hospital to visit his dying father.

Very few people believed Charlie would even live long enough to see his new baby boy. Four days later, on Christmas Eve, my brother Elbert arrived and took little Claude and me home. Charlie was taken home in an ambulance. To this day I don't know who made the arrangements for me or how it was even paid for. I just know that God was in it. I was now at home again with my husband and newborn baby. Once again, it was a happy and yet sad time for me at Christmas.

Verna Lee became very homesick in New York and begged to come back home to see her father and new baby brother. My sister also thought that it was fitting that she should return home to see her father before he passed away and decided to bring her back to Wilmington.

The days ahead were very stressful but I was grateful to God for allowing me to have the next three months with my family. People were so kind to us. There was plenty of food prepared for us and there were countless things done on our behalf that I probably never even realized. We had just completed a beautiful new patio behind our house before Charlie had taken ill. During these last few months at home, the debt for the patio was forgiven. The chiropractor who had tried to help Charlie with his back pain also forgave his bill.

There was a Jewish rabbi who lived a few miles from us. Rabbi Friedman had known Charlie for years, before I ever came on the scene, and he thought so much of Charlie. He was faithful to visit Charlie weekly and would read the Scriptures to him in an effort to comfort him. Many times he would bring kosher food to us, even though we were not Jewish. It didn't matter. He knew that God would expect no less from him than to aid others who were not able to give anything in return.

There were many times in those days that I found great comfort in my music. A few years prior to this, Charlie had surprised me with a beautiful new piano because he knew I loved music so much. What a blessing it was to us now because, while there was a great deal of sorrow in our home, I was always able to sit at my piano and play hymns that gave us such comfort and peace. Charlie would lie in the bed and ask me to play the hymns that we both loved so much. One of his favorites was "Pass Me Not, O Gentle Savior" by Fanny Crosby. Those last few days were filled with music that had such inspiring messages for us both.

Spring was almost upon us, and I could tell that Charlie's life was slipping away quickly. I felt so lonely and desperate that I called my parents and begged them to come and just be there with me. I just wanted someone to hold me and help me to be strong. Other family members would come and stay for short periods of time, but when Papa and Mama came they came to stay as long as necessary, even to the end.

Charlie began having convulsions periodically in the last days, which just drained him of any energy he had as well as put him in horrible pain. A local dental surgeon friend of ours heard about this and performed one of the greatest kindnesses you could imagine. He paid one of his own nurses to go to our home and give nursing care; she gave Charlie injections to calm the convulsions and ease his pain. It was difficult for me to imagine such selfless compassion, but I thanked God for providing again.

In the early morning hours of March 23, 1957, Charlie began fading fast. He quietly told me that he could see his daddy and that someone was coming for him. He then began having those awful convulsions again, and I suddenly felt overwhelmed with grief. I began to pound my fists on the wall and cry out to God that I couldn't stand to see him suffer anymore. Papa came to me and put his arm around me and said, "Virginia Lee, please turn him loose and let him go."

It finally dawned on me that maybe God was only keeping Charlie there until I was ready to give him up. Tearfully I told the Lord, "Father, if this is your will, then help me to accept this, because I can't stand to see him suffer like this any longer!" With that, I finally felt that I could let go and let the Lord complete His perfect will in our lives. Within the hour, the convulsions stopped and Charlie finally found peace. He passed away quietly with me by his side in his own home as Papa, Mama, and the nurse stood there beside me.

The sun came up that Saturday morning and a barrage of friends and family began coming to the house. Rabbi Friedman, who had spent so much time ministering to Charlie, came as well. Because it was Saturday, his Sabbath, he could not drive his car, so he walked several miles from his home to ours just to be with us and pray for us.

Claude was three months old and had contracted chicken pox. I had never known a child so young to have this nor did I know how he could have caught it, but somehow it helped me focus on his needs and made me realize that I had to be strong. I was grieving but knew, with the Lord's help, I would make

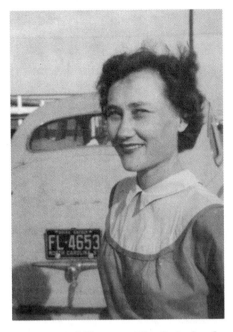

Virginia following Charlie's death.

it. Papa and Mama were still there with me, and I drew so much strength from them—especially Mama—because she was so very strong.

Mama was still recovering from her colon cancer surgery. She was having to learn a new method of performing everyday bodily functions that we all take for granted; yet she stood by me through the most difficult time of my life. Papa even shocked me when he said, "Virginia Lee, if you think it will help, go get one of your cigarettes." Until that moment, I thought that I had concealed my smoking habit from him.

Charlie's funeral was Sunday afternoon. Because it was on the weekend, many friends from all over the state as well as all of my family were able to be there with me. There was such an outpouring of sympathy and grief because Charlie was so well-known and so highly regarded. The funeral procession itself stretched for over seventeen blocks. As we rode through the town, my mind went back to that handsome and dashing man I fell in love with, walking the streets of Wilmington with his hat tilted to one side, whistling a happy tune, waving and greeting people everywhere he went. How fitting that so many would come to pay him tribute. He wasn't here any longer, but in my heart he was.

After Charlie's death it was very difficult for me to sit through a communion service at church without crying. I would remember how Charlie suffered and it reminded me of how much our Lord Jesus Christ must have suffered on the cross for our sins. It gave me a better insight of the agonizing pain that Christ paid for me.

10

Mama Shares My Loss

A New Journey Begins

Mama and Papa had returned to their home in Zebulon and she called me about six weeks after my husband's death to let me know that her own mother, Mammy Creech, had died. I was struggling to move on with my life without Charlie, and now I felt the familiar pain in my heart of losing someone that I dearly loved. This dear woman, the one who had led me to Christ as a young girl, was now in heaven with her Savior. I loved her so much, but I didn't have it in me to travel to attend her funeral. Claude was so small and recovering from chicken pox, Charles and Verna were in school, and I couldn't bear to go into a situation where people around me would be grief stricken. I was still so tender myself, and I just didn't want to open myself up to any more pain.

Things seemed to be happening too fast; problems were coming from every side, and I really had to lean on the Lord or I knew that I would completely fall apart. The days ahead were so very difficult but I knew that God had taken my husband and He would surely take care of us. I visited the Social Security Administration office to seek monetary benefits for my little family. We desperately needed some

assistance and I felt confident that this would help us survive. A few weeks later the Social Security office called and told me that Charlie did not have enough quarters paid into the system for me to be able to draw Social Security payments. In fact, he only lacked one quarter to be fully vested, which would allow us to receive assistance. I was devastated. How could we be so close to receive this assistance, yet be denied its benefits? It seemed so unfair.

I found out that the county started on the Social Security plan for their retirement while Charlie was ill. When the Board of Commissioners heard of my dilemma, they approached the Social Security Administration on my behalf and asked if they could pay the one-quarter retroactively. However, the request was denied. I didn't have any formal profession or trade to provide enough income to pay our bills and live a modest lifestyle, so I prayed to God, "Lord what will I do? I must have money to live, and provide for my three children!" Many of my friends and relatives suggested that I place the children in one of the orphanages for which they qualified. However, there was no way I would ever allow that to happen, as long as the Lord would help me, even if I had to scrub floors on my hands and knees.

It just so happened that, in the meantime, the Lord was working on the hearts of my sister and her husband, Donald, to invite us to come and live with them in New York until I could find a way to take care of us. Helen offered to keep my children for me while I decided what to do with our future. This was so sweet for her to offer to help me but I really did not want to move in with them in their home on Long Island. It just seemed so far from home.

New York was such a busy place, filled with all the things that would intimidate a young woman who was living on her own in a small southern town. I felt that I would have to enroll in a school of some type to learn a profession. And to move in with my sister and her husband seemed like it would be such an imposition. After all, they had no children of their own and I would be moving in with three, one being less than a year old. The idea just seemed preposterous, but the Social Security door had been shut and it became apparent that God had prepared this plan for me.

I felt confident that Helen could learn to be a mother to my children because she had always loved children so much. She was never able to conceive and have any children of her own, so I thought this arrangement could be beneficial to her as well as myself. My brother Douglas wanted to help me, so he offered to

drive the children and me to Long Island, New York. This had been a very difficult decision to make—to move that far away—but it seemed that I had no other choice.

Upon our arrival at our new home, I began to feel God's direction to enroll in a beauty academy. I felt this leading for two reasons: first, I thought it was something that I would enjoy and, second, it would not take long to complete, which meant I could start supporting my children quicker. Helen and I went into New York City in order to find the best school for me.

I decided on a school just across from Gimbel's department store. This was quite an experience for a small-town girl to go into a big city like this. I was not accustomed to trains and subways for travel to a job. This would mean my getting on a Long Island train at Hicksville and traveling half of the way to New York City. At Jamaica, I would have to change to a subway that would take me to my final destination just under the Gimbel's building. The travel time would be about an hour each way. This was unlike anything I had ever done because I had never been more than fifteen minutes from my workplace.

Once during this time that we lived on Long Island, we had a blizzard and I was caught at the school. When they finally realized how bad the weather would become, the school let out early. By that time it seemed everyone was trying to catch the same subway that I was to catch. I finally managed to get to Jamaica, but the train I needed to board was even more crowded. Some people were even hanging outside of the trains and between the cars. Never had I been in such crowded conditions in my life.

My sister was waiting for me when the train arrived in Hicksville, but the snow was so intense and there were so many cars that I had difficulty finding her. When we arrived home, the snow was falling so fast and the driveway was covered so deep in snow it took three of us shoveling continuously just to get the car into the garage.

The power was off and we had no heat or lights. Donald and Helen used candles and a kerosene space heater in order to have some light and a little bit of heat. They also had blankets to help keep warm. Our next-door neighbors were going to the Bronx to stay with their parents who still had power. They had a small baby and a little girl and felt that my children would be better cared for in the city, so they graciously took us with them. We were so grateful to have a warm place to stay that night. God once again provided for us.

God's provision extended past the fact that Helen and Don were providing food and shelter for us. My oldest brother, Elbert, was still in the Navy and one day I had a letter from his wife, Kathryn. In the letter she said, "You are my husband's sister and that makes you my sister, therefore we will be sending you fifty dollars each month to help." Kathryn reminded me of Naomi in the Bible because of what she said. I knew that probably would be a sacrifice because she had to live on a Navy salary and they had three children of their own.

I will never forget the love that my family showed me during this time. Helen was enjoying my children, especially my baby Claude, and she was so helpful to me. I was more than comfortable leaving my children with her because she loved them all so much and they loved her. I now understood God's providence in sending me there. It was fulfilling a need that Helen had, as well as providing a way for me to further my education, care for my children through loved ones, and eventually make a modest living for my family.

I had decided to again approach the Social Security Administration while in New York to reapply for monetary assistance. They studied my situation, but later reported to me that I simply did not qualify. It was then and there that I decided to give up that fight and I prayed, "Lord if you want me to have it I know you will just work it all out. I am failing in my own strength." I thought to myself that if God had provided for us up to this point, He certainly wouldn't let us down now. I just dropped the whole matter and continued working hard to learn as much as I could in school. I just wouldn't think about it anymore and let the Lord continue to provide other ways for us to survive.

One day, almost a year after arriving in New York, Helen called me at school and told me that I had received eight letters in the mail and that they appeared to be from the federal government. My first thought was, "Uh-oh, I wonder what's up now?" When I arrived home that day, my sister handed me the mail and I opened up the first of eight Social Security checks, the amounts being retroactive back to when Charlie passed away. I was so elated that I could hardly contain myself, for I knew that it had proven that I could trust in God for all of my needs.

When I stopped trying to do things in my own strength and started relying on God's strength, things began to happen. If I could have achieved this on my own, then I wouldn't have cried out to God for help and I would never have learned this valuable lesson in trust.

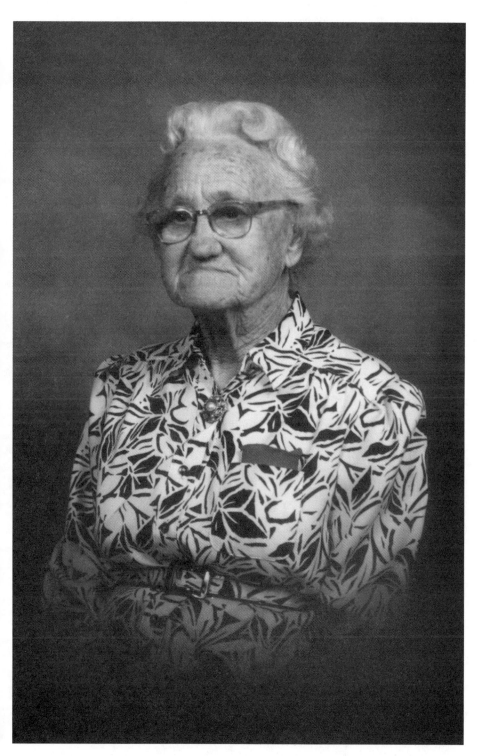

Mamie Creech Tippett.

Each milestone and each new tribulation in my life has caused me to grow closer to the Lord, for which I am grateful. Oh, how I wish I could pass this along to my readers. You must come to know God and trust His Son, Jesus Christ, to save you and then you learn that He always takes care of His own.

11

Where Do We Go From Here?

Time was passing quickly and I knew that I would have to consider where to go and what to do upon finishing my education. I was grateful for the help I was getting from my sister and her husband. Life was not always easy, though. Living under someone else's roof commonly creates conflict. There are always territorial issues—what belongs to whom, what is okay to share, and what should not be touched. I was a single mother trying to be as independent as possible, yet realizing that I had to ultimately abide by someone else's rules.

Don was a stern disciplinarian and much of the time he would bypass my authority with my children and do what he thought was best. I allowed this to go on for a couple of reasons. He was helping me survive, and I was living in his home. I also knew that he and Helen loved my children and only wanted what was best for them, but it was at times hard to bear. Don had a very important and stressful profession and at this time in his life would occasionally drink alcohol. While he was never abusive to my children, like many people, he could become very unreasonable and difficult to deal with under its influence.

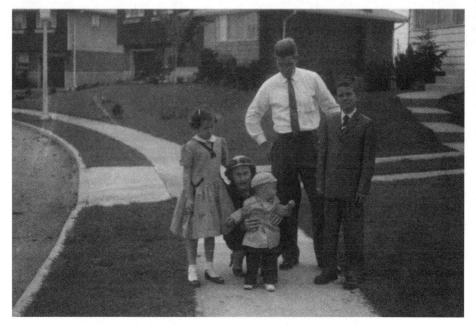

Helen, Don, Charles, Verna, and Claude in New York.

I finished school and while I was pondering what to do and where to go next, something happened at the house one evening that helped give me my new direction. It was on a weekend and all of us had been at a neighbor's house having a good time playing games, laughing, joking, and talking. We returned home and Don, who had been drinking, became irritated with me; he believed I had been flirtatious with the neighbor in the way I was joking and playing around. Of course, I would never flirt with another woman's husband, but Don's judgment had been impaired because of the alcohol and it must have seemed like I had done something wrong.

He confronted me about it in my bedroom and I, realizing that he was not to be reasoned with in his condition, just played it off. He considered my attitude to be flippant and disrespectful and he grabbed me by my arms and flung me across my bed and stormed out of the room. I wasn't hurt, but I was certainly humiliated and frightened. Don was a big man and very strong and I was shocked at being manhandled like that. I had already been sensing some resentment on his part because of living there for such an extended period, and I knew then that my plans needed to be in place quickly.

I needed to go someplace immediately to get away from the stress and get my thoughts together. My brother Elbert was always one of the wisest men I had ever known. He was still in the Navy, now stationed in Newport, Rhode Island. He and Kathryn had continued to send money each month to help me, so this seemed like a logical place to go for a few days.

The next morning I arose before dawn, gathered the children together, and we drove to Rhode Island. It was so good to see Elbert and Kathryn and their children, Bert, Kathy, and Ricky. Their love and attention was just what I needed at that time. They could tell that something had upset me, but they chose not to prod the information out of me. Instead they just showered me with love and let me know that I was welcomed there. I didn't want to unload any burdens on them or say anything to hurt Don and Helen, but I did tell them that I would be leaving New York soon and heading back to the South.

After the time spent in Rhode Island, I felt that the Lord was leading me to take my family to live in Virginia. My brother Douglas and his family lived in Portsmouth. He was about to retire from the Navy, so I called him to help me find work and a place to live. He knew many people and was familiar with the job market since he was already looking for a post-Navy career. He assured me that I would not have any trouble finding work as well as affordable housing. Having grown up in the South, I knew that I would feel more comfortable looking for employment there and, at the same time, I would have the benefit of being near some of my family.

Elbert and Kathryn Tippett.

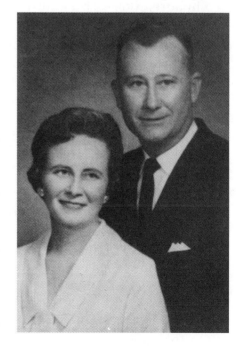

Most of my family members would be within a three-hour car trip if I decided to settle there. It had only been sixteen months since Charlie had died, and I felt the need to be near my family

because I was still mourning and needed their support and comfort. I also wanted my children to have the advantage of growing up near their family who could help love and nurture them.

Upon my arrival in Portsmouth I was able to find work right away in a local beauty salon. Doug had already begun asking questions for me, and he was the one who guided me to this particular salon. I also found a small house with four rooms that would be adequate for the time being, and it was located a short distance from my new job. I met and became friends with my neighbor across the street. I told her that I needed to find someone to care for little Claude while I worked and she said that she would be happy to help.

My other two children, Charles and Verna, were enrolled in a public school located very near our new home. This was convenient and they were able to walk to school every day along with their new friends and the other neighborhood children. With me now employed and the Lord providing Social Security benefits, I knew that I could care for all of us.

There was a problem, however. The government would allow me to make only a certain amount of income from working, and if I went over that amount they would take a portion of the Social Security benefits away from me. I always felt this was such an unfair law because it kept me just above the poverty level. One year, not realizing that I earned too much money, I was penalized and I had to send over two hundred dollars back to the government. That was a lot at that time and it hurt so much to return that money. But even though things seemed rough at times, I can look back and know that God supplied my every need. We may have wanted some extra things but we never went hungry and we always had a house in which to live.

Don and Helen missed my children so very much. This may have influenced them to consider adoption since it appeared that Helen would never be able to physically bear her own children. It was so exciting when they called informing me that they had adopted a beautiful six-week-old baby girl. She had golden blond hair and they named her Wendy Carol. She brought so much happiness into their lives and it would only be two short years later that they would adopt a sweet baby boy whom they named Eric. Don and Helen's lives were now changed and they were so richly rewarded for all their love and support for my family.

Once again, I realized why God wanted me to take my children to live with this couple in New York. It not only helped us, but it gave Don and Helen a taste of what it would be like to have children in

their home and it encouraged them to proceed with adoption. I wanted Helen to have her own children so much because she always loved being around mine. I can remember when she was very young that she loved little babies so much that if someone at church had a small one, she would head straight for it and beg the mother to let her hold it a while.

After settling in Portsmouth, Virginia, I realized that I needed to find a church in which we could worship. Fortunately there was one close to our little home. When I lived in Wilmington I would often visit Douglas in Portsmouth and we had gone with him and his family to Bethany Baptist Church, so I was already familiar with it and even knew some of the people there. I immediately began to make new friends and one of those ladies happened to be one of Verna's school teachers. She would later become a very dear friend, offering to help me in many ways.

When Claude was about two and a half years old, I noticed that he appeared to have a physical abnormality. When I took him to the doctor, he located a hernia and suggested that he have surgery. It seemed terrible for a child to have to endure surgery like that at such a young age. I was so discouraged to think that by the time one problem was solved, I seemed to encounter another. Claude did have the surgery and he recovered well afterward. I'm sure that having a small child was good for me because it occupied my mind, as the two other children were becoming self-sufficient. My friends in the church were very helpful during the time that Claude was ill, which I appreciated so very much. The people in my neighborhood, including the pastor from another local church, were also very thoughtful and reached out to help me.

I was still grieving over Charlie and it seemed that I would never get over remembering how much he had suffered before he died. It would always be imprinted in my mind. I found myself reliving it over and over because I would tell the story to every person I met. One day a loving neighbor kindly told me, "Virginia, you must stop reliving this story or you cannot survive." I believed that only God could help me so I prayed fervently to be able to let go, because my children needed me—especially my baby. I believe now that there were many others praying for me also.

God Solves My Problems With a New Love

One day at the beauty shop, the receptionist asked me if I would like to meet a nice gentleman who worked with her husband at the fire station. She said that, like her husband, he had been a firefighter for many years, was single, and very nice. I agreed, so we all gathered at my house one evening. His name was Sherman and he was thirty-eight years old, a rather robust man with a rugged face, a little taller than I, with deep brown eyes, and a bald head. He had a sweet, caring smile and was polite and mild-mannered, but I just wasn't too impressed in the beginning; maybe it was too early to start dating again or maybe I just wasn't ready to let go of Charlie. He also wasn't the suave, Dick Tracy-type like Charlie, who made my young heart go flip-flop.

Of course, I was well past that young girl stage. I now had a lot of hurt and pain inside and at this point, I wasn't sure if there was any flip-flop potential left in me. What I did notice right away, however, was that Sherman Goddin seemed to have a real connection with children. He took an immediate interest in mine, and they seemed to really like him as well. It was in October of that year, close to Halloween, when we introduced Sherman to the children

as Mr. Goddin. Their little eyes got as big as saucers, "Mr. Goblin?" they asked. "Wow!" Sherman let go of the biggest, heartiest laugh I had ever heard!

Soon after our initial meeting, Sherman started dropping in occasionally without any notice. At first it bothered me because it seemed a little forward. I mean, this man was coming around my home as if I was available. What would Charlie think about this? But suddenly it dawned on me that Charlie wasn't around and I was available, if only I would allow myself to be. So I decided to just sit back and observe what was happening.

I must admit that Sherman took up so much time with my children that it warmed my heart. What seemed even sweeter was that the children enjoyed Sherman equally as much. I started wondering who he was more interested in—my kids or me! On his days off from work he would invite the children and me to go all kinds of places with him. It didn't have to be a special outing. He would simply take us with him to the store, and we enjoyed his company so much. Soon, I realized that this guy was terrific and was so thoughtful and generous to us. I was amazed at his being able to love and care for my children so much. He had lived thirty-eight years and never married nor fathered children, but he was a natural if ever I'd seen one.

We had been dating a short time when I decided that Sherman should go with us one weekend to meet and visit with Papa and Mama. My parents had loved Charlie so much and they had been absolutely devastated when he died. It was hard on them to watch Charlie suffer so much and then to watch me struggle alone after he was gone. So I knew that it would mean a lot to them to see me find someone special to have in my life.

Papa and Mama took to Sherman immediately. They graciously welcomed him into their home and they told me later that it looked as if I had found a fine man. They had worried about me with my young children and the possibility of starting a relationship with someone who might not treat them well or who would have an ex-wife and children who might draw his attention from us. Sherman was unattached and ready to be a husband and a father. He exhibited a lot of fine qualities and it was all proof to my parents that he was up for the job.

After the nice weekend at my parents' home, I think I started getting cold feet. At that point he had never said that he loved me and I wasn't sure if he had intentions toward marriage or any kind of permanent relationship. I felt that it would be in his best interest, as

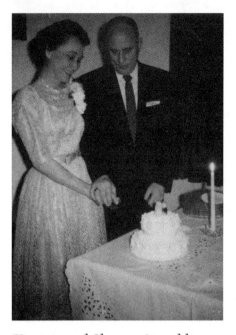

Virginia and Sherman's wedding.

well as mine, for us to take some time away from each other. This would help us decide if we really cared for each other enough to even consider a more serious relationship. I expressed my feelings to Sherman and he sadly agreed to it. I told him to refrain from calling me for a while and we would see how things went.

Days passed and we had no contact. I must admit that I was missing him. In fact I was missing him terribly. The children were missing him as well. I missed hearing that sweet voice over the phone when he would call. I missed his stopping in every evening to see us. After a week or so of this, I was almost to the point of picking up the phone and calling him myself. I stopped short of that because of my upbringing—I was taught that nice girls never call their boyfriends. Resisting the urge to call him, I thought I would go crazy!

Suddenly, at the beauty shop, a call came in to the receptionist who had introduced Sherman to me. It was her husband, and she turned from her desk and called out to me, "Virginia, Sherman has been in an accident with the fire truck!" My heart sank immediately. I prayed to myself, "Oh, dear Lord, what is happening?" I had a panicked look on my face when she said, "Come here, Sherman is on the phone and he wants to talk to you."

I ran to the phone and picked it up. I heard that familiar sweet voice on the other end saying, "I just wanted you to know that I'm all right; I wasn't hurt at all." I was so relieved. He went on to tell me that the accident was not his fault, a lady had run a traffic light and crashed into the side of the fire truck as he was responding to a fire. After telling me about it all he sheepishly asked me if I would consider seeing him soon because he missed me so much. That was all the encouragement I needed. I said, "You betcha!" He came over to see me the very next evening and when he walked through the door, I knew that I was in love with this man.

I began to wonder and talk to God about the possibility of getting married again. This was a wonderful man, but I had to know if it was God's will for me to marry him. If it wasn't, I wanted Him to please make it plain to me. I questioned Sherman in great depth about his beliefs and values and found them to be the same as my own. All the while, I was finding out how much I loved him and I knew that he felt the same about me.

About three months after our first date Sherman asked me to marry him, and that Christmas he gave me a diamond ring. I began to realize that there was happiness in life for me again. I wanted to marry this sweet man for he had all the qualities that would make a good father and a good husband. Two months later we decided to get married. We did not care for a large wedding, so we decided to have our minister marry us in the church parsonage.

It was only a short time after our marriage that the children began to call Sherman Daddy. I agreed with his decision not to adopt my children, because he said they had been given a good father, a heritage, and a name. He wanted them to have the identities with which they had been born. He would be their Daddy now and he would love them as if they were his very own.

Sherman went with us to church before we were married, but now he was taking us all the time. One thing concerned me, though, and I'm not sure why it didn't concern me earlier. Sherman wanted to become a member of our church, but he said that he had never belonged to any church before. I asked him about his salvation experience because he seemed like a Christian man. He was good and caring and morally upstanding. He had told me that he believed the same as I did, but I'd never asked him if there had come a time in his life when he made a conscious choice to ask forgiveness for his sin and allowed Jesus to come into his life.

His response to the salvation question was that as a little boy he thought he had accepted Christ as his Savior but when he arrived home from church, his father didn't think he knew what he was doing and discouraged him from pursuing it any further. Therefore, Sherman had never made his decision public nor received baptism in a Bible-believing church, thus he had never fully grown in his walk with the Lord. Now I realized why the Lord let me know it was right for me to marry this man. He used me to encourage Sherman to carry this a step further. Shortly afterward he talked with our pastor, arranged a time for his baptism, and he became a member of our church.

Modern Day Sarah

GOD PROVIDES A SON

*E*verything was so perfect and seemed too good to be true. My Heavenly Father had sent me the most wonderful man to love me and help me care for my children, and he was every bit as wonderful as Charlie had been. I had often heard that God doesn't close one door without opening another, and now I was beginning to believe that. God knew that Sherman was the one for me now. He already belonged to the Lord and we would not be unequally yoked together, as the Bible commands. Sherman only needed to get to a place in his life where he could grow and be the man that God wanted him to be. God certainly knew what we needed to be happy again, and Sherman was the man to share my life with. I always teased Sherman that he couldn't marry me for my money, so he married me for my children!

If I had gone seeking a husband, I could never have been this successful on my own. I would always be grateful to the Lord for Sherman and all he did for us. I wanted so much to find some tangible way to show him how much I loved and appreciated him. My thoughts and prayers began to direct me in a direction that

would certainly bless my new husband.

It was just over two years after Sherman and I were married that I began to be led in this new direction. It would be so nice if I could give Sherman a biological child to show him how much I loved him. He had never had any children of his own and he was so wonderful with mine that I felt he was destined to have his own. When I talked to him about it, he liked the idea but he was a bit concerned for me physically carrying and delivering another child because of my age. He was so sweet and told me, "Your children are my children now, and I couldn't love another child any more than I love them."

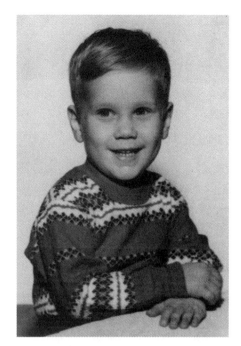

Waylan at age three.

He was so selfless and considerate, so I began to pray to God that, if it were His will, He would allow me to bear another child, this one for Sherman. I also asked God that if it didn't make any difference, would He please give me a son so I could name him after his father and together we would bring him up for the Lord. I just knew this would be the best way to really honor Sherman. I felt a little like Hannah in the Bible's first chapter of the Book of 1 Samuel. As I had done, she prayed to God and He blessed her with a son, Samuel, whom the Lord used mightily.

God did indeed bless me with a son. I was forty-one years of age when I delivered Sherman Waylan Goddin Jr. who weighed in at a whopping eight pounds, thirteen ounces! I had no trouble with my pregnancy or my delivery and, again, I knew that God had given me something special. Little did I realize, however, just how much God would continue to bless me with this son. He gave me so much more than I had asked for, and the days ahead would be filled with many wonderful surprises.

14

Almost Unbearable Nightmare!

Sherman and I were enjoying life so much with our four children. He was so proud of his baby boy. He declared little Waylan to be "the best thing to ever happen to the Goddin family!" and I believe he meant it. Things were just as wonderful as I could have hoped for them to be. We were a normal family. We had our share of problems, but we felt so blessed. The children, especially Claude, were all really enjoying our new baby.

The happiness and excitement of having a new baby in the house lasted for about eight months, when it appeared that we were going to face another crisis. Claude was about to turn seven when his pediatrician discovered that he had developed another hernia and he needed to have surgery again. He had just started the first grade so we decided not to remove him from school but scheduled his operation during the Thanksgiving holiday.

The day of the operation was a difficult one. When a child as young as Claude requires surgery, the parents undergo a lot of stress. The operation itself went well but Claude began having trouble afterwards. He couldn't keep anything in his stomach and would throw up regularly.

This lasted for about a week. Once the nausea ceased, the doctor allowed him to go home. That first night at home, however, he began vomiting again. The following morning I took him to see the doctor.

After an examination, the doctor revealed that Claude's heart was "pounding like a galloping horse" and he immediately sent us to the hospital. Once again we felt as if our lives were in a tailspin. We were already upset because of the current national events. We had just watched the funeral procession of President Kennedy on television that very morning and I had the strangest feeling—a feeling as though I was going to my own child's funeral. The whole world was still in shock. Everything seemed to be going in slow motion. Little did I realize what shortly lay ahead for us personally.

Claude was admitted to the hospital and it was determined that he was having heart failure. Then life just seemed to come to a screeching halt. Heart failure? My six-year-old son—how could this be? In the weeks that followed the doctors performed test after test trying to determine what had caused little Claude to go into heart failure. They even considered whether something had happened in the operating room, but nothing proved conclusive.

Claude was so sweet and such a loving child that he gained all the nurses' attention and they became quite attached to him. Every day they would take blood for more tests and usually when they did, Claude would whimper a little because the needles would hurt. After the nurses would take his blood, my precious little son would always apologize to them for crying and failing to act like "a big boy" and it would just rip at the their hearts. They hated going in and taking blood because they knew what they would be in for.

The days were passing and before we knew it, it was December 20, which was Claude's birthday. It had been seven years since God had brought this child into my life and what a joy he had been for me because he always seemed like a little angel. We spent Christmas at the hospital with Claude to make sure that Santa Claus came to see him on Christmas Eve. Even though he was very sick he still enjoyed his Christmas presents and that made us all very happy.

At the end of the year the doctors advised us to take Claude to the Medical College of Virginia in Richmond because the heart specialists could possibly discover more about Claude's heart and what was happening. The doctors thought it would be good for Claude to visit home with us for one night before proceeding to Richmond. It had been some time since he had seen his little brother, Waylan, and he

Claude Snow, the year he died.

was so excited to see him again. We let Claude get into the playpen with Waylan so they could play together.

I will never forget New Year's Day when we prepared to leave for the trip. Waylan was standing in his playpen fussing because he wanted to go with us. Claude reached in and hugged him good-bye and then turned to me with tears in his eyes and said, "I know I will never see my little brother again." It was a crushing blow. "Oh dear God," I thought, could Claude be right? Was this the last time that he would ever be at home? "Lord, have you revealed something to this child about his own fate?" I quickly tried to dismiss the thoughts.

It was a very touching scene as I left. I was feeling very low, leaving Waylan behind and then to be taking Claude so far away. I was grateful again to my family for stepping in to help care for Waylan.

Charles and Verna were in high school so they were able to care for themselves while I was gone.

It was a two-hour drive to Richmond and Claude was in good spirits. He would sit there in the car and play games with us and tease us. He would spot something of interest along the road, like a street sign of some sort, and he would exclaim, "Oh, oh, look at that," and by the time we could turn around to look at what he was pointing out, he would say, "Ahh, too bad, you missed it!" In his own sweet way he was easing some of the stress and fear that Sherman and I had by being so cute and funny.

Because of the distance between our home and the hospital, we were only able to make the trip every other day. When I did return, I would spend the entire day with him and then I could hardly pull myself away from Claude, always leaving at night after he fell asleep. Sometimes it would be snowing and very cold and that made the trip all the more difficult.

Before Claude became ill, he had begun learning to paint-by-number and one day while I was visiting, he asked me to get some paint-by-number pictures of Jesus. He had made a remark to my neighbor Nell, who babysat him, that someday he was going to heaven to see his father and Jesus. Now it had become extremely important to him to have these pictures. I left the hospital and walked in the snow a mile or more to find what he wanted. After searching through several stores I found two pictures that I thought he would enjoy. I knew it would also help him pass the time when I was unable to be with him and he was confined to his bed.

There was an almost continuous stream of physicians and student doctors entering Claude's room who were studying his condition. After a few weeks in the hospital they decided to transfer him to the rheumatic fever ward. I never found out the reason why they did this, but after the transfer they would only allow me to visit him during certain hours. We had given him a television for his other room, but in that ward he was not allowed to have it. When I left him that evening, I cried all the way home because it seemed things were getting more difficult and senseless all the time.

After about two weeks the doctors sent Claude back to the original building he was in. They told me that he was getting much worse and that I should remain at the hospital continuously. They provided me a room adjacent to his so that I might be close by and if I needed to get a little bit of sleep I would have a bed. But most of the time I just

Claude's unfinished picture.

stayed by his bedside. At one point his veins seemed to be collapsing and they finally had to draw blood from his legs.

One night, after the doctor had much difficulty finding a vein, he came outside the door and said to me, "This is what really breaks my heart. If only he would cry or yell at me it would make it much easier." I knew again that God had sent me a precious angel because Claude had always been such a sweet child and so different from many children. He was so easy to manage and had such a loving and sweet personality. I seldom had to be stern with him.

There were times when I felt that Claude was improving, especially the time when he asked a nurse for a banana sandwich. He had not been eating well so when he ate the first sandwich and asked for another one we were elated, feeling sure that he was better. Unfortunately, our excitement was short-lived. He was unable to keep the sandwiches down.

One Saturday night I stayed by his bedside all night because they put Claude in an oxygen tent and my motherly instincts told me to remain with him. I was standing beside his bed when I suddenly realized my son was dying. I ran out the door calling for the nurses and crying out that my son was dying. Within minutes the room was filled with people trying to revive him and they would not allow me back inside. Someone took me by the arm and led me down to the nurses' station because I was in shock. I could not believe this was happening to me. This was my child, the little angel that God had given to me who helped me through losing Charlie. My little Claude—now I was losing him, too.

It was Sunday, February 16, 1964, at 7:00 A.M. that God took Claude back to heaven. Through tears I stared at the paint-by-number pictures of Jesus that he had been working on. He finished one of his pictures, and the other one was only half finished. I called it the "Unfinished Picture" because it didn't have to be finished. Claude had been released from the pain of this world and was now in heaven where he could see what his Savior really looked like.

We had an autopsy performed on Claude so that we could discover more about his heart condition. The report revealed that he was born with a very rare disease called glycogen storage disease. One doctor told me that he had only seen two other cases and the children lived less than two years. This assured me even more of God's plan for me. He gave this child to me for a reason and let him live for seven years until He gave me Waylan. He bridged a gap and helped me keep

A Testimony

November 24, 1963, Claude Snow sat for the last
time to Pastor Bowman's right — on the front row in
Bethany Baptist Church. Now three months later he
is still sitting on the right, but in Heaven with
our Lord. He who made him and destined his life
from beginning to end planned it so. As his parents,
we thank God for having allowed us the privilege of
having him, our son, for these seven short years.
He taught us many things especially the meaning of
love, for we never saw a child or adult who had
more love than did little Claude.

We thank God for our many friends and the many
acts of kindness shown us during the illness and his
death.

If the homegoing of Claude can be the means of
reaching just one soul and bringing him to faith in
Jesus Christ, we will bow in humble submission to
our Lord and truthfully say that Claude had not
lived in vain.

We thank each of you from the very depths of our
hearts for everything that you did.

Sherman and Virginia Goddin

Church bulletin after Claude's death.

things together and when the work was accomplished, the Lord took
him back. I could see the pieces falling into place as if it were a puzzle.
More and more I knew that I could trust God who made heaven and
earth and surely He would take care of me. Yes, I did grieve for a long
time over the loss of my precious little boy, but I knew God would see
me through it all.

It was only one week after Claude's funeral that our oldest son,
Charles, had to enter the hospital for an emergency appendectomy.
We were still walking around aimlessly, just going through the
motions, trying to put our lives back together again and now Charles
was ill. This wasn't a serious illness and aside from the pain and
discomfort associated with this unexpected operation, he would
recover quickly.

But we were becoming a little concerned because this would be the third hospital bill, plus a funeral bill that we were going to have to find a way to pay. Claude's hospital bills had to be incredibly high because of the treatment he received and continuous around-the-clock care given to him. My faith did not waver though, for I knew God was in charge. My husband was still young in his faith, so I felt I needed to be strong for him. I believed in tithing to the Lord, so regardless of all the bills, I knew I had to encourage Sherman to do the right thing with our money. I told him to trust the Lord and He would see us through everything. We continued to tithe our money and gave a minimum of 10 percent to the church because we believed that part belongs to the Lord.

Even though God had been so gracious to me and proven His love and care for me over and over again, I still was shocked at what happened next. A few weeks following Charles's surgery, without any explanation, I received a report from the Medical College of Virginia about the bills saying I owed nothing! I cannot explain why, except that God paid those bills for us. It was once again proven to me how important it was to put God first in my life.

Recovering from Loss

BLESSING OF A NEW SON

After Claude's death on February 16, the days ahead were busy ones for me. Charles was graduating from high school and preparing for college in the fall and I went back to work part-time. We were not desperate for money, but we wanted Charles to be able to get his education so that he could become self-sufficient. Verna would also be entering college in three years and the demand for extra money would be even greater.

Sherman's days off were the days that I would work and that allowed him to care for little Waylan. This gave Sherman a chance to spend quality time with our son. Sherman may have been a bachelor when I met him, but he learned quickly about caring for Waylan and could do anything that I could do. He really was so very happy having a little son named for him.

Sherman would take Waylan everywhere he went to show off his son. In every store they visited, he would buy a little something for Waylan, such as candy or a small toy. I really began to worry that all this would spoil our little boy, but thankfully it turned out he wasn't too easily spoiled. Again I realized that when God closed one door for

me, He always showed me where another was opened. There were so many things that happened that I couldn't understand at the time, but I do understand somewhat better now even though there were many more painful days ahead.

It was in Charles's third year of college that he was married to a fine Christian girl by the name of Alice Drinkwater. He had known her for several years, growing up together in church and dating through high school. She was a wonderful young lady and from a fine home. Sherman and I were so happy that they decided to marry and establish their home together.

They were married during the darkest days of the Vietnam War and we were grateful that Charles was not drafted. Sure, we were patriotic and loved our country, but after losing a child we cherished our children more than ever and appreciated life so much more. The war was a difficult one and the horrors of those taken into captivity or killed frightened us terribly. Many of Charles's friends had to go to Vietnam, and at one time he was even called up for his draft physical. But the Lord had other plans and was in total control. Instead, he was given a college deferment, followed by a critical federal job deferment, and then he was blessed with drawing an extremely high draft lottery number.

Verna was in her first year of college when she met a fine young man who was studying for the pastoral ministry. His name was Bob Reese. He was a friendly young man, kind and respectful of others. They began seeing each other and immediately knew that God had brought them together. Some time prior to Verna's departure for college she had felt God calling her into some area of Christian work. I had encouraged Verna to apply to one of our Baptist-supported schools—Bluefield College—because I thought that she needed a good education in a Christian environment. I thought this might point her in the direction that the Lord had for her life. Charles had attended this school for two years, and I knew it to be a fine one. And, if nothing else, she would have a better chance to find a good Christian husband! When I found out that Bob had asked her to marry him we were all elated. Amazingly, Charles had also known Bob in college.

This was the Christian work that God had planned for my daughter. A pastor's greatest asset is a loving and faithful wife to care for him and be his partner in the ministry. I was so pleased that my children were selecting fine godly mates because that was my prayer for their lives.

Waylan was five years old when Verna was married, so my home was starting to feel a little empty. We now needed to concentrate on getting Waylan into a kindergarten somewhere. We enrolled him in a public school that was within a mile of our home, but after a couple of years in that school, God began to lay on our hearts that we should place him in a Christian school. So when he finished third grade, we took him out of the public school and enrolled him in the Christian school that our church had started. With Charles and Verna on their own, we had more money to provide for a good education for Waylan. The world was a fast-changing place and things were tougher now. Public schools were no longer allowed the benefits of public prayer. Violence in the schools was becoming commonplace and illegal drugs were plentiful. We felt this school would provide a safe haven in which our son could learn and grow as a Christian.

It was while he was still in public school at age five that Waylan started showing some interest in my piano. He would sit at the keyboard and try to pick out little tunes that he had heard, or make up little tunes from the notes that sounded good to him. One day I asked a friend of mine who was a piano teacher if she thought it might be a sign that he had some musical talent. She knew that I had a little knowledge of music so she gave me a primer music book and told me to try working with him. I know that I was anxious to see that he had some talent, but I could see immediately that he was interested.

Sherman and I loved the way that our church pianist played the piano, so we asked her if she would consider teaching Waylan. Her name was Louise Ray and she was a sweet and gracious Christian lady. Her musical style was unmatched by any non-professional that we had ever heard. We would hear her play and it was as if the music literally rolled off of her hands. She used great, sweeping, rapid chords (called arpeggios) that sounded as if she were playing a harp. She was absolutely inspiring and we were so grateful when she agreed to work with Waylan.

We thought he was learning quickly, yet I had a difficult time getting him to practice his music homework. Waylan didn't mind sitting down and playing the piano, but it just wasn't always what his teacher had given him to practice. Mrs. Ray told us that Waylan always asked her to play through the piece of music first, so she started to suspect something more was going on.

Mrs. Ray decided to perform a little test on him. She would sit at the piano and tell him to sing the pitch of a certain note. When

Virginia's children—Waylan, Verna, and Charles.

he would sing the note, she would play it on the piano and the pitches would match perfectly. Then she would have him turn his head and she would play a note and ask him what the note was, and he would get it right every time. Her suspicions were correct. Waylan had what is known as a perfect-pitched ear, which is very rare. This answered a lot of questions as to why he was progressing so quickly in his music.

Waylan had taken piano long enough to be accomplished on the keyboard, but his sight reading for notes was way behind. He, of course, didn't realize he had a deficiency in this area. But he was smart enough to realize that if he had Mrs. Ray play his assignments for him first, he would remember it, which assisted him in learning those pieces. He would then play them perfectly for her on the next lesson.

Mrs. Ray started teaching Waylan to play hymns from our church hymnal and he immediately began improvising and adding lots of extra notes to the hymns, beyond those that were written on the page. We were beginning to think we had a real pro in the making. As it turned out, Waylan was also very inspired by Mrs. Ray and he did his best to imitate her style. While this was all so wonderful, it made it much more difficult for him to learn proper music reading because his

ear was so strong. He struggled to read the music that was unfamiliar to him, but the hymns were already familiar so he picked those up with amazing speed.

We knew Waylan had to learn to read the music though, and it became a constant battle to make him work at it. But Mama won the battle. I knew God had richly blessed Sherman and me with a child who had a special gift. I had promised God I would do my very best to bring Waylan up for Him, so to me that meant pushing him with his music. I thank God for the extras He threw in over and above a fine healthy son. I have had so much enjoyment just listening to him play. I once told his teacher that if she never taught him anything other than Christian music I would still be happy. I have continuously prayed that God would anoint Waylan's music so that when it falls on people's ears they would be blessed by hearing it. God has accomplished this to this day, by placing him as the church pianist in one of the largest and fastest growing churches in the Tidewater area of Virginia.

16

I Share My Brother's Tragedy

*I*t seemed that things were going great in our lives when yet another shock came along. Living nearby, my brother Douglas had three wonderful teenaged children, Brenda, Donnie, and David. His middle child, Donnie, was quite a young man. Donnie loved the Lord and was very active in our church. He loved to sing and play the guitar. He was a fine looking fellow, so tall that he had to duck when walking through the doorways in the house. He had a magnetic personality; people were just drawn to him. Everywhere he went he had a group of young people around him.

Donnie had been having some problems with his back and the doctors had been unable to find his trouble. It had to be serious because seventeen-year-old young men are normally active and energetic and don't give in to their pain easily. The hospital performed several tests, yet could not come up with a diagnosis; they finally decided to do an exploratory operation. We were not quite prepared for the outcome of the surgery.

The doctors discovered that Donnie had cancer behind his kidney and it had grown and spread to the point that they could not remove

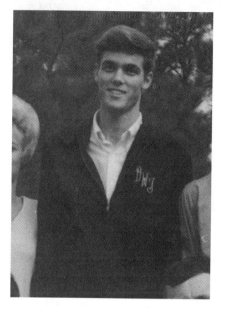

Donnie Tippett.

it for fear of him bleeding to death. He was given chemotherapy but it never seemed to help and he was so nauseated from the treatments.

It was almost a year later that Donnie had to reenter the hospital. One morning after getting up, I felt the urgency to go to the hospital to see Donnie. When I explained that to Sherman, he encouraged me to go immediately. When I arrived at the hospital, I found out that Douglas needed me to stay with Donnie so that he could go home, get a shower, and rest just a little. He and his wife, Peggy, had spent the night there because Donnie had grown much worse.

I talked with Donnie and he responded even though I could tell that he was almost incoherent. He was in the Portsmouth Naval Hospital and his ward nurses were Navy men. One of them approached his bed and was trying to administer a pill, but Donnie would push it away. Feeling the need to go to him, I knelt beside his bed and said, "Donnie this is Aunt Virginia and I'm right here with you. Please listen to your nurse for he is trying to help you." Donnie almost immediately sat up on the side of his bed, pulled the oxygen out of his nose, took the pill in his hands, and swallowed it. This big, tall young man whose body was giving in to the cancer still had amazing energy.

I continued to remain by his bedside that morning when suddenly, I saw my nephew taking what appeared to be his last breaths. I had watched both my husband and child die, and I was aware of death's appearance. I ran over to a nurse and told him that Donnie was dying and immediately he was surrounded by doctors and nurses.

I realized that this was probably the reason God had directed me to go to the hospital that morning. Doug had barely departed the parking lot when Donnie started dying. I don't know why God provided for Doug and Peggy to be gone, leaving me by Donnie's bedside. But I believe it may have been to spare them that anguish of watching their son die and perhaps I was a bit more prepared. I had

ample time to call Sherman and Pastor Bowman. The doctors asked me to let them call Doug and Peggy, so they all arrived at the hospital about the same time.

I don't believe anyone expected Donnie to die so quickly after fighting such a good fight for over a year. I had often prayed that if it were God's will, He would perform a miracle and heal my nephew. I thought this would show the world that He still healed people, and Donnie's leadership among the young people in school and church would be rewarded. God didn't see fit to bless my request, but I was to find out later that He would give me a great blessing anyway.

Tribulations in Texas

My daughter, Verna, and her husband, Bob, had been in Fort Worth, Texas, for a short time where he was preparing for the pastoral ministry at Southwestern Baptist Theological Seminary. They had already given us our first grandson, Robbie, the previous year, and despite the demands on their time, they returned to Chesapeake, Virginia, to attend my nephew's funeral. On returning to Fort Worth they took Waylan along to visit them, and after a few weeks Sherman and I would travel there to pick him up. Waylan spent a total of six weeks with his sister in Texas, and even though he loved her dearly, it was a little more than an eight-year-old could handle and he was ready to see his Daddy and Mama again.

Verna and Bob found out in the fall of 1971 that they were expecting another baby, due the following July 4. This was such a happy time for them. Bob was in the middle of earning his Master of Divinity degree, they had a beautiful home, and they were now expecting their second child.

About this time, Bob became interested in transferring to another seminary in Louisville, Kentucky, to finish his studies. During the

months that Verna was expecting, they prayed diligently for God's direction, but somehow Verna wasn't quite comfortable with the prospects of this move, even though it would place her a little closer to her family. She and Bob usually agreed on most of their decisions, but she couldn't find peace with this move. She began to pray that God would show them what was right for their lives. If the move to Louisville was not what He wanted, she asked God to do whatever was necessary to show Bob that the move was a mistake. Bob, however, felt sure that going to Louisville was the right move and he put their home up for sale.

On July 1, Sherman, Waylan, and I were on our way to Texas, hoping to get there before the new baby arrived. We really wanted to be with Verna and to help Bob because Robbie was an active little boy of two and a half years, the house had just been sold, and the baby was due at any time. We felt that they needed us to be there. Verna delivered a beautiful baby girl on July 6, 1972, and she was named Annette.

Both mother and daughter seemed to be doing well at first, but Verna began having horrible spinal headaches for no apparent reason. Her doctor felt there was no cause for alarm, but he decided to keep both Verna and Annette in the hospital for an extra three days for observation. Bob and Sherman decided to use this opportunity to make a quick trip to Louisville to secure housing for the family since their house in Texas was now under contract.

After locating and placing a deposit on an adequate apartment, Bob and Sherman returned to Texas just about the time Verna and Annette were released from the hospital. Verna was only home for a day or so when the headaches became so unbearable that the doctor readmitted her to the hospital. Sherman and I stayed to help care for the children until Verna was stable and ready to return home.

The doctors began putting Verna through a battery of tests and she seemed to be doing better, so after a week she returned home again. Thinking she was fine now, we decided to start the journey back to Virginia because we had our job responsibilities. Bob and Verna were very active in their church and had many friends there as well as at the seminary, so we knew they would be well cared for.

My brother Elbert and his family were now living in Nashville, Tennessee, so we always stopped there to spend the night, to break up the trip and to have fellowship with them. Over the years I had developed a very close relationship with this family. Elbert, being the oldest

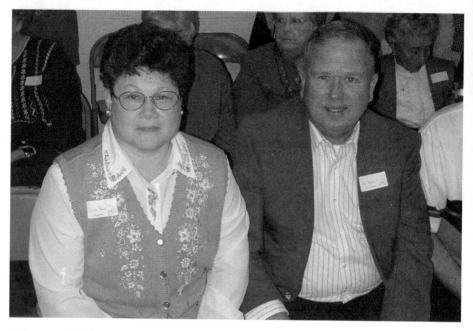

Verna and Bob Reese.

of my siblings, was a great spiritual guide for me and would impart such wise counsel whenever we talked. He and Kathryn had been so precious to me and I was anxious to take advantage of every opportunity to visit with them. This was another one of those occasions that we would enjoy. The next morning we left in the very early hours in a heavy fog. I remember the fog being so thick that I prayed that God would help us avoid an accident.

We had been home only a few hours when the telephone rang and I was surprised to hear that it was from Bob. He began to tell me that Verna's headaches had become much worse and she was again in the hospital and a neurologist had been called in for consultation. He was doing tests on Verna to find out why she was having such severe pain, thinking of the possibility that she might have a brain tumor. A brain tumor? The words stung me with a searing pain. "People die from brain tumors," I thought. I had not even unpacked my luggage, but my family needed me. No matter what, it was absolutely necessary that Sherman and I go back to Texas now.

After we had called our respective employers, we headed down the road again for another fourteen-hundred-mile trip to Texas. Just prior to leaving, we called our pastor and asked that he and all our

church family pray for Verna. I had so much faith in prayer and I knew God could do anything. We decided, as we had done previously, that we would take turns driving, so I began with the first part of the trip.

It was a terrible night traveling back because we were both already exhausted from having just completed this trip a day earlier. Now I had a severe headache from a combination of exhaustion and worry, and it stayed with me until we arrived back in Nashville at 7:00 A.M. the next morning. We had only planned to stop in Nashville again for an hour or so to rest and tell Elbert's family about Verna.

Elbert took one look at me and said, "Virginia, you and Sherman are coming in to have some breakfast and then you're going to lie down and get some rest." I replied, "No, Elbert, we must get back to Texas. Verna and Bob need us right away!" But Elbert responded with that familiar brotherly love and concern and firmly said, "You *will* eat something and you *will* lie down and get some rest or I will be forced to drive you on to Texas myself. End of discussion!" We did as we were told, and I was too tired to argue at this point. After Kat prepared a wonderful breakfast for us, we took a nap. I felt as though I had passed out for over two hours and I didn't even remember my head hitting the pillow. Soon afterward we were on our way again.

Upon our arrival in Fort Worth, we went directly to the hospital to see Verna and to get the test results. We were told that three neuro-surgeons had all conferred and had diagnosed Verna as having a brain tumor. Our fears were confirmed. "Oh dear God," I thought, "It's really happening! My little girl could be dying!"

Verna was to be operated on immediately for the mass on her brain. It seemed as if this was a horrible nightmare and I would surely awaken from it. Here was a dedicated young man, Bob, studying for the ministry with a two-and-a-half-year-old son and a newborn baby girl. How could he take care of all of this if God called Verna to heaven? I suddenly realized that there was a good possi-bility that Sherman and I might have to help raise these grandchildren because Bob's parents were deceased and we were the only living grandparents.

Sunday, the day before the surgery, everyone in their church was asked to pray and to call around to other local churches to pray for Verna. We again called back to our home church to make the same prayer requests. There was an outpouring of support and encour-agement like I had not seen in a long time. Many friends from

around their community offered to donate blood, bring food to our home, or to keep the children for us. It seemed everyone wanted to do something to help.

That Sunday afternoon I dressed baby Annette in the prettiest little outfit I could find and took her over to the hospital straight to her mother. I didn't even bother to seek permission to take her into her mother's room. I placed the baby on the bed beside Verna and my mind quickly returned to 1957 when I had placed my baby Claude on the bed beside his daddy, who lay dying. It was a tremendously emotional moment for me, but I had to believe God was still on His throne and that His plan for our lives was perfect.

The next morning there were many people joining us to wait while Verna's operation was underway. We appreciated seeing how much people cared, and that really helped us with our anxiety. We knew that it would be a long wait. As Verna lay on the gurney preparing to go into surgery, Bob, Sherman, Waylan, and I all spent a few private moments as a family to express to her how much she meant to each of us. I looked at my precious daughter and gently kissed her forehead and told her that I loved her. I knew that it could be the last time I would ever speak to her.

A few hours had passed when, finally, one of the doctors came out to talk to the family. He told us that they had bored two holes in the top of Verna's head to put air in the brain, thus pinpointing the exact location of the tumor. "Why is he out here telling us this stuff?" I thought to myself. "Shouldn't he be in there taking care of Verna?" He had already educated us on what the procedures were and how long they would last. Now he was already dressed again and acting like he was finished with the job. The look on his face gave me a sick feeling because I couldn't tell if he was getting ready to give us some terrible news or if he was bewildered by what he found. He proceeded to tell us that as soon as this procedure was started the tumor disappeared. He was completely baffled by it. All the tests, X rays, and all three doctors had confirmed it.

Well I sure knew what had happened, for I knew God had answered many prayers that had gone up in her behalf! It was another miracle in my life and even though God didn't see fit to heal my nephew when I had prayed for a miracle for him, He had blessed me with the healing of my own child. This reminded me of the scripture in Ecclesiastes 11:1, which says: "Cast thy bread upon the waters, for thou shall find it after many days."

While Verna was recovering, Sherman and I helped Bob move since the house had been sold and the new owners were taking possession. Bob had secured a small apartment near the seminary that would be adequate for them for now. By this time it was too late for him to get into the seminary that he desperately wanted to attend. Evidently God answered Verna's prayer about this decision, for she had asked Him to do whatever He saw fit—even if it meant using her. It appears that is just what He did. God accomplished a two-fold purpose in all of our lives. I also thanked God for giving me such a wonderful husband as Sherman who stood by my side all the way and by a daughter who was not even biologically his child. He could not have done more for us than he did.

Bob graduated that year and had an enticing offer from a church in the western states, but he turned it down because he felt that God wanted him to return east. He finally did get an invitation from a church in New Jersey where his former pastor was located. After the interview it was decided that this was not the place that God had intended for him to go. God works in mysterious ways and I was soon reminded again that God's plan is not always our plan.

The church that interviewed Bob paid all the expenses for him to take his family to New Jersey, and even though that was not God's plan, it was part of a much larger plan for this young family. While visiting with Sherman and me, there came an even better opportunity for Bob. I am so glad that my Heavenly Father knows the past, the present, and the future, and when we let Him direct our paths we will not go wrong. This was certainly no exception. Proverbs 3:5–6 says: "Trust in the Lord with all thine heart; and lean not unto thine own understanding. In all thy ways acknowledge Him, and He shall direct thy paths."

That better opportunity for Bob was offered by a church, which eventually called him to be their associate pastor. The church was here in Virginia and only about an hour and a half from our home in Chesapeake. In just a few short months I would learn just how much that would mean to me in the days ahead.

18

Please Lord, Not Again!

The following spring, Bob and Verna moved to their new home near Petersburg, Virginia, to start his ministry as the associate pastor of Matoaca Baptist Church. It was so thrilling to have them close by us and I was going to see them almost every weekend. I had not had my grandchildren living so close before and I enjoyed seeing them often. I didn't realize that I would soon go through another valley.

Sherman was still working as a firefighter and occasionally he would earn an additional day off which would give him three days off in a row. He always looked forward to these days because he could relax or work in his wood shop and just enjoy it. He was a fire captain in the city of Chesapeake and he worked very hard. Therefore, I was always happy to see him relaxing and enjoying himself. He deserved it because he was such a wonderful man. He managed to get one of these three-day holidays in September 1973, just a few short months after Bob and Verna had moved back to Virginia.

On these particular three days Sherman didn't do a great deal of relaxing. He had lots of energy, working hard to accomplish many things that he had been meaning to do for a while. He did lots of

repairs around the house, replaced worn-out items, and did some painting as well. In the midst of all that, he even took time to do a little Christmas shopping, which surprised me because it was only September. Christmas still seemed a long way off to me.

One of the rages for kids at the time was the ten-speed bicycle. He wanted his son, Waylan, to have one for Christmas. So he went shopping and found just the right one, purchased it, and stored it at a family member's house for safekeeping. He returned home and before he finished his time off, he changed the oil in my car and performed some other minor repairs on it. This all seemed unusual, but I just thought he had become really energetic or maybe he was just feeling well.

He had to report back on duty the twenty-ninth of September, which was a Saturday morning. I didn't hear from him all that day until he called at his usual time—10:00 P.M.—to see how my day had been and to say goodnight. At that time everything seemed to be all right and I said, "I'll see you in the morning." I knew he would be home at 8:00 A.M. on Sunday morning and we would all go to church together. Waylan was already in bed so I began to get ready for bed myself.

It was near midnight when I received a telephone call from one of the firemen and he told me that they had gone out on a local fire call and that Sherman had been overcome by smoke. They had already transported him to Portsmouth General Hospital and they wanted to let me know right away so that I could get there to be with him.

I quickly awakened Waylan because I couldn't leave him home alone. He was dazed and confused, asking what was going on. I told him, "Daddy has been overcome by smoke and he is in the hospital! We have to go!" He didn't really understand what all of this meant and immediately became hysterical. He began saying that he had begged his Daddy to stop smoking because it might kill him one day. I quickly explained that Daddy's condition had nothing to do with his smoking habit. He started crying saying, "Mama I just know my Daddy is going to die." We hurried to the car, and I was having a difficult time keeping my composure because Waylan was so upset.

I raced through the streets of Portsmouth to this downtown area hospital, running through any traffic light that threatened to slow me down. Waylan was terribly upset and now I, too, felt as though there was a cloud of doom over us. He kept crying that his Daddy was going to die. Over and over he repeated this all the way to the emergency room. It was very difficult for me to drive and try to keep Waylan calm at the same time.

Sherman in 1969.

When we arrived at the hospital they would not allow me to see Sherman and I could not get anyone to tell me about his condition. I did get a glance through a hallway door of my husband lying on a bed with doctors and nurses all around him. They appeared to be working diligently on him, and I could see his arms and legs twitching just a bit in response to their treatment. As the nurses would come in and out of the room, they acted very calmly as they passed me in the hall. As soon as they would get far enough from me, I noticed that they would begin running as if the situation were urgent. I thought to myself, "Why would they be running that way?" I just couldn't allow myself to believe that this sense of urgency was because of Sherman's grave condition.

God had placed a Christian friend of mine there at the emergency room that night for something totally unrelated to my situation, and she suggested to me that we go into the snack room and pray. Sherman's brother, Harry, was also there at the emergency room, so I left Waylan with him. We began to pray and moments later I heard a door slam open against a wall and Waylan came screaming down the hallway toward the snack room, "Mama! Mama! Daddy is dead, Daddy is dead!"

Immediately, it seemed as if time stood still. Waylan was inconsolable and I was now in complete devastation. "How could this happen?" I wondered. All that I could manage to say through my tears was, "Why, Lord? Why? Sherman was so good! He was so good! I need him here with me!" It didn't seem real. Surely this was a horrible nightmare from which I would soon awaken.

About the same time we had begun praying for Sherman, the doctor had come out and spoken to Harry and Waylan, informing them that Sherman had just passed away. Waylan at ten years of age didn't even understand what that term meant and asked the doctor, "Are you saying that he's dead?" The doctor nodded his head to confirm, and Harry began crying and that was when Waylan went running for his mother. What a horrible thing to say to a ten-year-old boy when his mother wasn't even with him.

It seemed as though Waylan must have known all along that his daddy was going to die. He was exactly the same age as Charles was when he lost his father. I was in severe shock, thinking that this could not be real. I was married eleven years to Charlie and thirteen years to Sherman. God had given me two wonderful husbands and now he had taken both away from me. I have to admit that I began to question God.

I have often heard that lightning does not strike in the same place twice. I couldn't believe that God would so quickly take a second good husband from me and still I had another son to raise alone. I recalled what my mother said to me many times when things get tough, "You just do what you have to do." Sometimes I did wonder if the Lord was aware of me—maybe I was a little nobody or maybe He had forgotten me. Still in my heart I felt God surely had a purpose for allowing these things to happen to me. He certainly had drawn me closer to Him because I had to rely completely on Him. I shudder to think where I would have been otherwise.

I began to see God's purpose when He had led Bob and Verna to move closer to me. He knew they would be of great help and comfort to me. In the meantime, Helen and Don, along with their young children, Wendy and Eric, had moved from New York to Wilmington, North Carolina, their original home. When my sister and my daughter received the news of Sherman's death, they were both with me by daybreak, even though it was a good distance for each to drive. Charles arrived from Atlanta a short time later. What a comfort to have family to always stand by you when you need them. I know these principals of family love and devotion were so strong for us because of the way Papa and Mama lived their lives. They were such wonderful examples to us all.

I could not believe how many friends Sherman and I had until I saw how people responded to his death. He was a public safety employee and a ranking official within the city fire department. Coupled with the fact that he died in the line of duty, it became more widely known and publicized through the news media. There were firemen from everywhere and people that I had not seen in ages offering their condolences.

When a public servant dies in the line of duty, there is a tremendous outpouring of grief and sympathy as we saw in our nation's September 11, 2001, tragedy. Sherman's death was no exception. He was a fine man who was well-known. He was active in his church and played a strong role in his community. No one was a stranger to Sherman. Like Charlie, people knew him for his good nature and kindness.

On the day of his funeral I was amazed to see the number of people in attendance. Our church was filled to capacity and people were standing outside in the rain. As our car pulled up to the curb we saw what looked like one hundred firemen and policemen lining both sides of the sidewalk to the church, all standing and saluting us as we

Virginia at age forty-four.

passed through. It was a fitting tribute to a man who cared so deeply for others and gave his life proving it.

When Sherman and I said our goodnights that September evening, the last words we spoke to each other were, "I'll see you in the morning." How true this was because as the old hymn says, "I will meet you in the morning, just inside the eastern gate . . ." by Albert E. Brumley. We will meet again one day in heaven.

Single Parent Challenge

A Good Home for My Son

During the days following Sherman's death, I began to learn that God wanted me to be at home for Waylan. I knew that it was important for me to be there for my growing young man when he returned home from school. I also knew that I had to continue working to get him through grammar school, high school, and college. My older children went door-to-door through my neighborhood to solicit the neighbors's signatures on a petition, which would allow me to use my home as a beauty salon. My neighbors were in 100 percent agreement with my proposal, which I took before the city planning board and they approved it as well.

When Sherman and I had constructed our home, we added an extra room as his workshop as well as a utility room. This eleven-foot-square room with a rear-door entrance was to become the perfect beauty shop. I believe it was all a part of God's original plan, as this room was added to our plans at the last minute before construction.

Several men in my church, together with my brother Douglas, all gathered at the house to help convert the utility room into a beauty shop for the building inspector's approval. They installed new

paneling, painted the trim, installed a suspended ceiling with new lighting, covered the concrete floor with a vinyl floor covering, and provided the required plumbing modifications necessary for a nice shop. All these were necessary to meet the city's requirements.

Many of my existing customers became customers in my home shop and many of my neighbors became my customers as well. This was a great boost to my income, but because the government would limit my Social Security to an income ceiling, I had to eventually cut back. I had the same trouble when Charlie died, and it barely gave us enough to survive.

I still detested this law because, at fifty-two years of age, I was still young enough and able to work; therefore, I could have provided better for my own future and not feel fearful I might have to struggle when I retired. When I reached seventy years of age, the government said I could now make all the money I wanted without penalty; but by the time you reach that age, you don't have the same stamina. My income from my work alone was not enough to make it without Social Security, and yet to get the Social Security, I was limited on the amount I could work. The city at that time did not have a very good retirement system and since Sherman had only paid a small amount into the plan, I drew it out.

At the time of Sherman's death the state had an insurance plan that paid benefits to the families of all policemen and firemen who died in the line of duty. Somehow, I had difficulty in getting this insurance, even though Sherman's death was definitely in the line of duty. I would need a doctor's certification that the smoke and stress from fighting the fire had contributed to my husband's death. I had an autopsy performed and it showed that he had an artery that was partially closed which may have been a result from his smoking habit. For this reason it seemed that no doctor wanted to get involved in helping me, and I chased from doctor to doctor to determine if fighting the fire had shortened Sherman's life.

Finally I said, "Lord, only You know my entitlement to this insurance benefit." I was in exactly the same position as I was in New York following Charlie's death seeking Social Security benefits. I would again have to leave it up to the Lord and trust in Him. I went on with my life, working and caring for Waylan. I had learned before that God had provided for me so why should He change that now? I was still His child for the scriptures told me so, and He had proven that to me over and over again in my life.

Waylan Goddin at the piano.

I had the pleasure of meeting a couple soon after Sherman's death who really encouraged me. Dr. John Hunter, with his lovely wife, had been invited to our church as a guest speaker. He and Mrs. Hunter were both known authors and educators from England and had written several books on the Holy Bible. I had them, along with my pastor and his family, into my home for dinner one evening. He was aware of my recent loss and gave me many verses of scripture to encourage me. They all explained to me how God dearly loved the widows and fatherless children.

This gave me more assurance for Waylan and myself and our futures. How God blessed me just by inviting one of His children for

dinner. It reminded me of the way my parents invited the ministers into our home when I was a child, yet at the time I was unaware of the blessing they received by doing so. Because of what had been instilled in me, I could now, as an adult, appreciate and experience that blessing as well. I was hurting at that time and his kind words and encouragement helped me so much. Now I know the importance of encouraging others who are hurting as well. Again I was reminded of the lesson that God wants us to pray about things and turn them over to Him. Then we need to get out of the way so He can show us what He can do.

Time passed quickly and I kept myself busy between my son, shop, home, and church work. Then one day when I went to the mailbox, there was a letter I thought I would never get. I had a check from the insurance company for benefits on which I had given up. God had shown His loving care for me once again by providing me with this money. As long as I tried to do things in my own strength I failed. But when I committed it to God, He took care of it and all I had to do was praise Him and give Him all the credit He was due. I hope that I will always remember, come what may, Lord, You have never failed me at any time.

God Provides a New Illness To Break My Old Habit

When trials come to you, as they did me, so many times we have the tendency to turn away from God. He doesn't want us to do that; He wants us to draw closer to Him, pray, and let Him take care of the situation. He uses life's difficulties to strengthen us even though He may not necessarily cause difficulties. I have had a hard time learning this lesson in my life. Now I realize that God was trying to purify me, and it has taken Him a long time to do that. I know He wants me to be more Christ-like so others might see Christ in me. The God who made me surely knows what is best for me.

For many years I had a problem that I knew did not please the Lord. I had tried and tried, but to no avail, to break the habit of smoking. Yes, I prayed for ages asking the Lord to help me with this addiction and still I couldn't stop smoking. I was so embarrassed that I started trying to hide it from everyone, not realizing that people could smell it on me. I wasn't fooling anyone but myself, so I became even more frustrated. Each time I had tried to stop, it was so painful that I would go back to smoking. Smoking was a crutch for everything that happened to me. I had to have a cigarette for

everything: when I was hungry, after a meal, when I was nervous, when I was under stress, before going to sleep, and the first thing when I awoke in the morning.

Then one day it seemed that God was saying to me, "If you don't stop smoking, the cigarettes and the hair spray you constantly breathe will destroy your lungs and you will die!" I cried out to the Lord and acknowledged that I was completely helpless and would never be able to stop without Him doing it for me. I asked Him to help me to want to stop more than I wanted to smoke.

God doesn't always answer our prayers on our time schedule. Sometimes He chooses to test our faith for a while. If you belong to Him, He does eventually answer your prayers. It wasn't too long after that prayer that I experienced some neck problems. The doctor sent me to the hospital and there I remained for quite some time. I was put in traction and was constantly having tests performed. It was during this time that I could not smoke because of another patient in my room.

After being released, some of my family members came to stay with me for a while. Because they thought that I had kicked the smoking habit quite some time ago, I couldn't exactly ask them to go out and buy cigarettes for me. I would have been embarrassed to admit to them that I still smoked and that I had hidden it from them all this time. I wrestled with that withdrawal from nicotine for what seemed like years and suddenly, one day, I felt I had passed the crisis. Occasionally after that I would think how good a cigarette would taste and then I would say, "No." That little visit from my family helped keep me from falling right back into that trap once I was released from the hospital.

The Lord had heard my cry for help and again, when I stopped relying on my own strength and turned it over to Him, He helped me. He helped me even though I had to be placed in the hospital, but it did start my recovery from cigarettes. You should be careful of the things for which you pray, because you may get exactly what you asked for! Everything that was ever accomplished in my life of any good, I have given the Lord Jesus Christ the credit for being there for me. Romans 8:28 says: "And we know that all things work together for good to them that love God, to them who are the called according to his purpose." He works everything for our good.

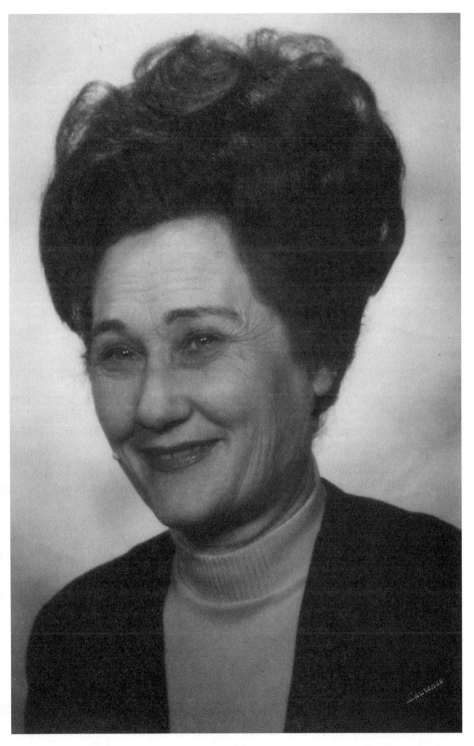

Virginia at age fifty.

21

Renewed Spirit

MY TRIP TO THE HOLY LAND

God never wants His children to remain in a valley. I believe that as you pray and strive to live for Him, He always gives you something special after going through a valley. He will pick you back up and set you on a mountaintop. On one such occasion, God gave me a real mountaintop experience.

I have a dear friend who is a great man of God who was helping to lead a tour group of the Holy Land comprised of some local church members and good friends. The Rev. Ted Bashford (whom we lovingly referred to as "Brother Ted") still continues as the executive director of the Union Gospel Mission in Norfolk. He was interim pastor of my church at that time and felt it would be such a blessing for me to go. He didn't want to take no for an answer. You see, I had been actively praying for God to help me draw closer to Him through the reading of His Word, the Holy Bible. I asked Him to create a greater desire in me to read and study my Bible more. So, I began to think, "If I could just see the Holy Land with my own eyes and walk where Jesus walked, maybe it would inspire me to read my Bible more." I suddenly was excited about the prospects of this trip and what it could mean to me

94

spiritually, and I told Brother Ted he could count me in for the trip.

Peggy, my sister-in-law, decided to go along on the trip with us. My brother Douglas thought it would be something she would enjoy and benefit from as well and he graciously encouraged her to go with me. This gave me some wonderful companionship as well as a roommate.

We left Norfolk International Airport for the Kennedy Airport in New York where we picked up a Jordanian Boeing 747 to Amman, Jordan. Landing at the airport in Jordan and needing a rest room gave me a real appreciation of the conveniences that are readily available in our country. Privacy and cleanliness were two things that they were obviously not concerned with.

From Jordan, we took another airplane to Cairo, Egypt. We arrived at about 9:00 P.M. and were finally fed at about 11:00 P.M. It was a welcomed meal because we had not eaten well that day at all. Since it was so late, we did not have time to explore the city, but we awoke early the next morning and took a bus tour of Cairo and the surrounding areas. I was so excited when I saw the Nile River. I had read all my life of the Bible story where Moses, as a baby, was put afloat on the river to be saved from the merciless, murdering hand of Pharaoh, only later to be rescued by Pharaoh's own daughter. All of this was God's plan because He protected baby Moses, using him later to lead His people, the children of Israel, out of the bondage of slavery in Egypt. This made me realize even more that God has a plan for all of His children.

We went to Memphis, where we saw the Sphinx and the Pyramids. We stood in awe of the temple where the Moslems worship, and as we entered the temple we were required to remove our shoes in an act of respect and reverence. We traveled to the Mena House, where Winston Churchill, President Franklin D. Roosevelt, and Josef Stalin met for the Yalta Agreement during World War II.

After lunch there, we toured the city of Cairo, where we saw so much ruin around the buildings; it really does look like the oldest nation in the world. As we crossed the Nile River again, I was reminded that these people don't have the luxuries that we have in our country or the things that we take for granted. I saw a woman laundering her clothes there in the river and, a little further along, some people were bathing a donkey in the same water!

People were selling bread out in the open street markets, unwrapped and available for a feast to all the flying insects. How I appreciated the modern grocery store and the sanitation laws we have to protect our health.

Peggy Tippett at the Mediterranean Sea.

The city has its share of cars, but there were no traffic lights that I could see. It was frightening to see the traffic moving so quickly and chaotically. It appeared as though no one knew who had the right-of-way. Even more unsettling was seeing people riding their camels along and mixing with the traffic as well. Later we stopped, and anyone in the group who wanted to was given the opportunity to ride on a camel. I will admit that it didn't seem like a very dignified sport, so I encouraged Peggy to take a ride in my place and she did! I will never forget the grace and dignity she exuded as she perched herself on top of that camel.

We stayed nearly two days in Egypt and it was long enough for me to thank God for the privilege of living in the United States of America. We flew back to Amman, Jordan, and there we took a bus trip to Israel. Crossing the border was quite an experience because they opened and examined everything in our luggage. Even the most personal effects were inspected. For some people the experience was almost as humiliating as standing undressed in public. Even one of Peggy's suitcases was completely emptied out onto a table and the suitcase itself was put through an X-ray machine.

Funny, she didn't appear to be a terrorist to me, but maybe she looked suspicious to them!

As we traveled toward Tiberias, we saw the Hebron Valley, Jordan Valley, Samaria Mountains, Mountains of Gilead, and the Moabite Mountains. Seeing these geographic sites reminded me that buildings and earthly possessions come and are gone after a few years. These things that were mentioned in the Bible were here in Jesus' time and remain here even today. Many things in this region have changed, but some things will always be here.

It was particularly exciting to see the greenest of all valleys, Jericho, where we stopped and had lunch. They had fruits of every kind and they were tremendous in size. The strawberries were almost the size of a tennis ball and I saw cauliflower the size of a ten-gallon hat. Jericho is thirteen hundred feet below sea level; it is the lowest point of land on earth and has the perfect climate. With a place like this that had such rich and lush vegetation, it is no wonder God wanted His people, led by Moses, to go into the Promised Land.

We saw the Qumran Caves where the Dead Sea Scrolls were found, which proved even more that the Bible is authentic and accurate. Our first night in Israel was in a hotel on the Sea of Galilee in Tiberias. I almost didn't sleep that night for looking out at the sea that Jesus traveled upon, the one He walked upon, and the one in which He and His disciples fished. The next morning I had an opportunity to take a boat trip on that same sea, and I was thrilled as we rode to the other side to Capernaum. There we saw what is believed to be the place that Jesus cast the money changers out of the temple.

We went to the quiet place where Jesus gave the Beatitudes in the Sermon on the Mount. It was very solemn and reverential. You couldn't hear any kind of noise. No wind, birds, bugs, or traffic. It is also believed that Jesus fed the five thousand there. We traveled on to Caesarea, Philippi, and saw the snow-covered Mount Hermon, which is thought to be the Mount of Transfiguration. We stopped at the border of Syria at the Hills of Bethsaida, the land where the Six-Day War was fought. Then later we saw the Village of Nain, where Jesus raised the widow's son after he had died.

We saw Megiddo, where the Bible teaches the Battle of Armageddon will be fought. That is referred to in Revelation 16:16. We left Tiberias and traveled to see Mount Carmel where we saw a statue of Elijah. This is the mountain mentioned in 1 Kings, where Elijah tested the god of Baal against his true and living God with the

sacrifice where fire fell from heaven consuming the sacrifice and even the water that had been poured on it.

From Joppa we saw the great Mediterranean Sea on our way to the Mount of Olives where we stayed for the night. From our hotel room, we could see the city of Jerusalem as well as the Dome of the Rock. This is supposed to be the rock where Abraham offered up his son Isaac as a sacrifice. We had to remove our shoes before entering the shrine. When we were ready to leave, Peggy and I found that our shoes were missing. What I discovered was that some of our tour group were playing a trick on us because I saw them giggling at how panicky Peggy was when she thought she would have to leave the Holy Land shoeless! We did get our shoes back, and I must admit that I was relieved.

We traveled to see Masada, a shrine for the Jews, near the Dead Sea. The Dead Sea is just unbelievable. It is fifty miles long and about nine miles wide. It is about one thousand feet deep and 30 percent chemical because it has no outlet. The heat of the Jordan Valley evaporates it, leaving the deposits in the sea. We visited Hebron, where the tombs of Abraham, Jacob, Isaac, Rebecca, and Sarah are located. We were also at Mamre, where God told Abraham that Sarah would have a son late in life. From here Abraham went to rescue Lot.

We went to Bethlehem, which was one of the greatest places we visited because this is where Jesus was born. He was born in a stable, but not in a stable as we know it. It most likely was a cave-stable. Even as a little girl, I remember singing "Oh Little Town of Bethlehem," by Phillips Brooks, never dreaming that I would actually go there one day. All of the Christmas hymns were written because of Christ. Had He not been born, there would be no Christmas.

We later saw the Pool of Bethsaida, which was believed to have healing powers. We saw Golgotha Hill, Tomb of the Kings, Garden of Gethsemane, and Church of the Nativity. It was very touching to see people praying at the Wailing Wall. We traveled on into the old city of Jerusalem and shopped. We saw the Upper Room, where the Last Supper was held before Jesus was crucified.

As I walked on I thought about a song that has since become very dear to my heart, "I Walked Today Where Jesus Walked," by Daniel S. Twohig. Some things I had been seeing and touching were there when Jesus walked there. It was beginning to make me want to search the Scriptures more. When we came to the Jordan River, some members of our tour group decided to be baptized there. We saw what is supposed to be the point of the Jordan's origin in the mountains.

We left Jerusalem and traveled to the border of Jordan to visit Petra, a rock city. Our guide told us that the Romans had carved this city out of the mountains. We traveled two hundred miles by bus to get there. In order for us to get into the rock city we had to ride upon donkeys for two and a half miles. We each had a guide to walk along with the donkey to keep him going. The entrance was so narrow, only the donkeys could take you into the city; as we approached the entrance, I was sure my donkey would be too big to fit. He did make it in carrying me on his back, and it was awesome to see how the city was completely carved out of rock. As we traveled through this area we saw what appeared to be burned coal for miles. The guide indicated it might have been the site of Sodom and Gomorrah. We saw places that had some vine-like growth that had about one-and-a-half-inch thorns. I was reminded that it was probably thorns such as these that were placed upon Jesus' head. If it were so, it was awful to even think about it for they were so sharp.

After about ten days of traveling we started for home and it was a great thing for me to have made the trip. It gave me a better understanding of the Bible and a greater love for it and my country. It was

Virginia (far lower right) in Jerusalem.

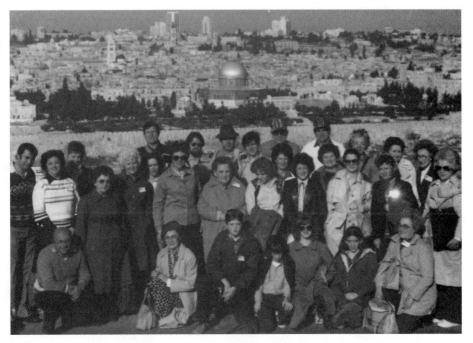

good for me to see that some places in the world do not have all that the American people take for granted. The trip helped me to think about my spiritual condition and I really believe God wanted me to have this blessing. As a result, my purpose for going was fulfilled. I felt closer to God than ever before and had a strong craving to dig into His precious Word and know Him even better. It was a part of His plan for me.

22

Storm Helen

My Sister's Own Tribulations

*H*elen and Don, after many successful business years in New York, had returned to their roots and were now building their retail business in Wilmington, North Carolina. Their children were in their teenage years and they were now able to be closer to their aunts, uncles, and cousins. They had not enjoyed the privilege of growing up around their relatives and seeing their family on a regular basis.

Being the only two girls in our family, Helen and I had always been very close. We could talk to each other about almost anything. I had always loved this family so much because of what they did for my children and me at the time of Charlie's death. It seemed when everything was so perfect for this family, we were all in for a great surprise.

Helen was always the more energetic of the two of us. I was fun, too, but I was not the vivacious, bubbly, outgoing girl she was. She had so much personality and was loved and adored by all who knew her. I used to be a little jealous of her when we were young because, at times, I thought that even my parents liked and catered to her more than me, especially Papa. She was the sparkle in his eye and deservedly so. She was a cutie and was always into some mischief.

The beautiful thing about Helen was the incredible woman she grew up to be. She had style and flair like very few women ever achieve. Helen could put on any dress or hat and look like a million dollars. She had timeless beauty—medium ash-blonde hair swept up in the latest and smartest style and, as she grew older, she had a distinguished gray streak that started at the front of her forehead and fanned out through the rest of her hair. When she flashed that smile and caught you with those sky blue eyes, she could sell you waterfront property in a desert.

Helen also became a savvy businesswoman. She never went to college but she learned about life and business through the school of hard knocks. Don, even with his college education and post-graduate degrees, had a rare and most precious jewel in his wife because she literally became his right hand. Most of his business success and monetary blessings could be attributed to having Helen by his side.

About a year and a half after Sherman's death I had a call from Don telling me that Helen was sick and was facing surgery. Helen then got on the phone with me, thinking she could probably keep me from being alarmed. She went on to calmly explain that her doctor had performed various tests on her and suspected that she had a brain tumor. She hesitated to call it that, only describing it as a "cyst sort of thing" and that it was probably nothing to worry about.

Helen knew that I might become upset considering what I had been through with Verna, so she spoke about it in a rather routine manner. Her trouble began when she awoke one morning and could not remember certain words, especially names and nouns. She would start to say, "I need to fix . . ." and could not remember the word "breakfast," or to instruct her son to "Go and mow the . . ." and couldn't get the word "lawn" out. Even while talking to me about a Billy Graham Crusade on television, she couldn't recall his name. She described everything about him until I finally guessed that it was Billy Graham she was referring to. I immediately made plans to be by her side.

She had already been admitted to the hospital when I arrived in Wilmington, North Carolina, and they had already shaved off her beautiful hair. Things were happening too fast for me. I could not believe that my sister could have a brain tumor but that is what the diagnosis was. I went to Don to speak privately with him about this and I begged him to seek another opinion about Helen.

I reminded Don that as a young girl Helen had been hit in that area of her forehead by a baseball bat. Our brothers were playing in

Helen in 1943.

the yard one day and Helen happened to walk behind one of the boys as they started to hit the ball and of course the bat struck her in the forehead. We were all frantic because she had a large lump the size of a golf ball on her little head. My parents doctored her with home remedies but she was never taken to a doctor.

I told Don that the mass may have been there all of her life because it was a serious injury. I asked him about the possibility that something else had happened to Helen, possibly some mini-strokes. I knew that if they operated on her brain that the results of the surgery could be devastating and that Helen may never be the same again. Even more alarming was the fact that she could die during the surgery itself. Don disagreed with me, saying he had the utmost confidence in Helen's doctor and this was what was best. I just knew in my heart that this was wrong.

Tearfully and reluctantly I admitted that I had no control over this situation, but I felt it just wasn't right. Don seemed to be oblivious to the fact that this could all change life as we knew it. I made my way to my sister to spend a few minutes with her and let her know that I loved her and that I would be there waiting for her to come out of surgery. She squeezed my hand and her pretty blue eyes just danced as she smiled up at me, "I'll be fine, you'll see."

What strength she had. I drew from that strength, remembering that during every crisis of my life, Helen was there for me. When Charlie was sick and eventually died, Helen was there. When I lost my little boy, Claude, Helen was there. When Sherman died, Helen was there. She always performed many tasks for me that most people would never think about, even down to sending acknowledgements from the family for flowers given in bereavement. She was strong and was always watching after me. Now, it was my turn to be strong for her.

The family waited anxiously in the waiting room for what seemed like an eternity. My heart sank when the doctor finally emerged from the surgery. He told us that she did not have what he would consider to be a brain tumor, but he found some type of gray mass in the fore-head area and removed that. Helen stayed in the recovery room for a very long time and we began to wonder what was taking place. Finally we learned from the doctor that my sister had a stroke while in the recovery room and was now in the intensive care unit. I believed then, and I still believe, that the doctor made an error in his diagnosis and that as a result, she was in far worse shape than she would have ever been in.

Helen, Mamie Tippett, and Virginia.

My precious sister was put through a terrible operation for apparently no good reason; I believe that she had had a stroke to begin with. I thought that the surgery, perhaps, had caused her to have the second stroke.

I didn't have the opportunity to see her until at least a day later. We could only go in for fifteen minutes at a time. I approached her bedside and looked at the shell that hardly resembled my beautiful sister. Suddenly she looked like she was one hundred years old, instead of the energetic forty-nine-year-old that she was just the week before. I looked at her face, struggling to find something familiar about it that would comfort me and let me know that it was still my Helen and that she would be okay. She looked up at me with those familiar sky blue eyes that had such life and spunk, although now they looked tired and sad.

I told her, "Don't you worry, girl. You are going to be okay. I won't leave until I have made sure of it." She couldn't utter a single response, but I could tell in her eyes what she was now feeling. They just stared up at me, helpless and defeated, and tears began to trickle down out of the corners. My heart was broken. I knew she would never be the same.

I don't think Helen had any idea that she would come out of the surgery and be experiencing what she was now going through. She lay in the hospital for a long time without walking or talking with anyone. She was not even able to feed herself or able to control her body or any of its functions in any way. We began to think she would not live or ever leave her bed. We kept praying and she did finally go home but she had to have nurses around the clock. We hoped and prayed that she would eventually be able to talk and have some way of communicating with us. One day, Don and I were with her and he was brushing her teeth. I just chatted along with her, even though she was not responding verbally. She would nod occasionally and cut those eyes at me like she was completely aware of all that was going on. As Don finished with her teeth, he held the cup up to her mouth and told her to spit the toothpaste out. She refused (she always could be a little stubborn). I smiled because it reminded me that Helen always had a mind of her own. This was a way she showed some control in a world where she no longer had any control. Don kept working with her to spit that toothpaste out and she just looked at him. I thought, "Well, maybe she likes the way the stuff tastes!" Don finally decided that he was going to win this battle and he took her by the cheeks and started gently squeezing them together, making her little mouth pucker until she gave up the toothpaste. She then glared at him and she uttered her first words since the surgery. She said just as plain and clear as anyone could, "You're just damnation to me!" Don and I looked at each other in amazement. We were so pleased to finally hear her voice again, and then we had to laugh because of what she said. It was the closest to a curse word that I had ever heard my sister utter.

A therapist had to teach Helen how to do everything, even how to take care of her personal needs. It grieved me to see my sister so helpless for she was still young and I could not do a thing to help her. I knew that there was one thing that I could still do and that was to pray for her.

Helen survived and has recovered somewhat but she will never be the same person that she was before the surgery. She still has trouble recalling certain words, therefore she and I have never been able to talk things over as we used to. It has been painful for me and confusing to her, but we still enjoy seeing each other. That has never changed. I lost a lot that day in 1974 when my sister had that operation. But God was gracious in allowing her to at least recover enough to walk with some assistance and live a quiet life around her family. It amazes me

that while communication is a struggle for her, she can do one thing as well as she did before her strokes. Just as she did as a child, Helen still loves to sing. She can't carry on a great conversation anymore and she still has a difficult time recalling certain words, but when she takes a songbook in hand she can still sing beautifully and doesn't miss a single word. As a matter of fact she goes to church every Sunday; that same familiar determination she's always had still pushes her. She is a member of the choir and she faithfully sings in her place at every opportunity, even if someone has to assist her into the choir loft.

She has been an inspiration to all of us. God knew what a good mother and wife Helen was, and I believe He spared her life so she could see her children grow up. She continued to be a loving wife to Don, right up until his death in July 2000. She continues to live in her own home with the assistance of her daughter and grandson who live with her.

I will always believe that Helen learned how to be a good mother when she took my children and cared for them after Charlie's death. She was wonderful to them and they grew to love her as more than just their aunt. No one could have done a better job than my sister in caring for them at such a tender time in their lives. To my children, she was the next best thing to Mama.

Waylan's Tribulation

It was the year 1979 and life was busy for me. Our church was growing and looking to secure land to build a permanent sanctuary for us. In the midst of this excitement, Waylan had his sixteenth birthday and was finally driving a car on his own, a day that most kids look forward to. But, only a few days later, I received the dreadful news that my Papa had passed away peacefully in his sleep. I was grateful for having had him so many years and, even though I grieved when he died, I knew he was in a better place for now he was walking again and on golden streets. I was very tender at this time in my life and sought the Lord daily to sustain me.

Remember I had promised the Lord that for giving me a son for Sherman I would do my best to bring Waylan up for Him. I had to do this by myself now. I suppose I may have failed in many ways but I really did try to lean on the Lord for His direction. I could see Waylan's possibilities in his music, so I encouraged him in every way to become a great musician. I decided that if he never played the piano or the organ in any setting other than in the Lord's work I would be happy. I expressed this to his piano teachers and they

focused their instruction and his training toward this goal.

At ten years of age Waylan had his first opportunity to play at church as a substitute. This was good training because when he grew a bit more, around fifteen years of age, he was asked to be the pianist for our newly chartered church. He had become very timid in the years following the death of his father, but through prayer and encouragement along with the responsibility of playing for his church, Waylan really opened up musically and overcame his timidity. God blessed him and he hasn't been timid or nervous since.

It was the Christmas season when Waylan was sixteen and our church choir had just presented its annual holiday musical on a Sunday evening. Waylan had played for the entire musical and I knew he had to be physically worn out. After the service, while people were cleaning up and preparing to go home, Waylan seemed really tired and said that he wasn't feeling well. I took him home so he could go to bed, thinking that he was drained, his resistance was low, and he might be coming down with some kind of illness. Just before going to bed, he said that his chest was hurting. I gave him some medicine and some juice and sent him on to bed. I tried not to be alarmed, thinking that it could not be anything very serious.

Early the next morning I started working in my beauty shop, and I decided to go in and check on Waylan since he was sleeping later than usual. When I went into the house, he was lying on the sofa and in tears, sweating profusely. The first thing he said to me was, "Mama if you don't take me to the hospital I'm going to die." The words hit me like a brick. Waylan didn't usually complain much when he was sick and for him to use words like that frightened me more than one can imagine!

I had just finished with my customer so I rushed out to let her know that Waylan was terribly ill. She said she would wait with me until I contacted the doctor to see what I should do. I called our family doctor, Dr. Powell, the same one who had taken care of all of us since Sherman and I were married. I told him what Waylan's symptoms were and described the pain that he was in. Dr. Powell immediately recalled the heart illness that took the life of my son, Claude, and told me to take Waylan straight to the hospital. He was going to call in a heart specialist and meet us there.

The weather was absolutely horrible that morning. The rain was coming down steadily and my customer who was waiting to find out what the doctor told me offered to ride along behind us to the hospital

Waylan at age sixteen.

to make sure we got there safely. I was grateful for her concern and was happy to have her company as well.

We arrived at the emergency room and they took Waylan in immediately because he already had two doctors there waiting for him. They hooked him up to monitors, started an I.V., drew some blood, and ran a battery of tests. In a short time the doctors came to me and told me they were admitting my son and placing him in the coronary care unit. They continued by telling me that there was something wrong with his heart. The specialist went so far as to say that the enzyme levels were extremely high and that if Waylan were a man of fifty years of age, he would diagnose him as having a massive heart attack. Once again, it seemed as if my life were thrust into slow motion and I was watching everything from a distance.

The doctors were so concerned after putting him in the cardiac unit that they thought I should probably spend the night there with

him. They thought it would make Waylan feel more secure and relaxed if I was nearby. This was most unusual. No one was allowed to stay with a patient in the coronary care unit. In fact, families were only allowed to visit the patients for only a few minutes on the hour.

I learned that some of the nurses didn't appreciate my being there, but Waylan's doctor carried considerable weight with the hospital and had a lounge chair rolled into his room for me to sleep in. Dr. Powell had always taken extra special care of Waylan because of what had happened to Claude. He made sure no detail was overlooked in his health care and I was so grateful for his watchful eye.

Our pastor and friends in our church began praying for Waylan. They were all aware of the anxiety I was feeling, knowing I had already lost a child to heart disease and had lost two husbands as well. Our pastor, George Pierce, came to visit with me that next night. He told me that he had awakened just before sunrise that morning and had driven to the property where our new church building was being erected and he just stood in the middle of it all. Right there, among the first building blocks and partially finished walls, he just prayed that God would spare Waylan's life and that He might use Waylan and his music for the glory of God. He said that he felt a certain peace about everything. Surely God would not have gifted Waylan this way and given him so much talent to use for the Lord, only to have his life snuffed out at such a young age.

I went home that night because Waylan appeared stable and I needed to rest and get some fresh clothes. I also had a couple of customers to attend to the next morning, since it was almost Christmas. My daughter, Verna, was also getting on a plane to be with me and would need to be picked up at the airport. I told Waylan that I would be back the next afternoon.

By the next morning, the heart specialist called me to advise me that I had better come to the hospital. My heart sank. I asked him immediately, "Why? What is happening? Has something happened to my son?" His only reply was a very cool, "Mrs. Goddin, you just need to get here right away." My mind was reeling. "This is what they say to you when someone is dying!" I thought. I couldn't think straight. I knew that customers would be on their way to my house and that Verna needed to be picked up from the airport, but I had to get out of there and get to my son.

I saw my first customer driving up in the driveway and I immediately ran outside to meet her as she was getting out of the car. I was

frantic and in tears and all I could get out was, "Oh dear God, I'm losing another one! I'm losing another one!" I will never forget how sweet this dear lady was. She remained calm and took me by the hands, telling me to go to the hospital. She said she would take care of everything, including meeting Verna at the airport.

I climbed into my car and headed for the hospital as she went into my house to call the rest of my customers and cancel their appointments. Then she went to the airport to get Verna and my youngest grandchild, brought Verna back to the hospital, and then went back to my house with the baby to care for him the rest of the day.

When I arrived at the hospital, I found that Waylan was violently ill. He was vomiting over and over again. They were having a difficult time with him and were worried about dehydration. The rest of the day was intense because he was so sick and we didn't know what was wrong. Another team of heart specialists had been called in from another hospital in Norfolk to help diagnose Waylan's heart problem. Word had traveled throughout our church and community about Waylan's condition and by that evening the hospital waiting room was filled to capacity with friends and family all waiting to find out what was happening to him.

The doctor came in and told us that the diagnosis was pericarditis, an infection of the pericardium or the outer lining of the heart. It was considered rare at Waylan's age and was quite serious. He continued that Waylan was the youngest patient ever to stay in the cardiac care unit of the hospital. Verna and I pressed him for more information. We wanted to know if there was a possibility that Waylan could die from this condition. The doctor shook his head yes.

The doctor's answer set off an emotional wave in the room that was indescribable. There were quiet tears. There were people walking out into the hall and openly showing their emotion and disbelief. There were people holding hands and praying. People were calling other people to have them pray for Waylan. The concern at this point, according to the doctor, was that Waylan was so sick and that the medication did not appear to be working. We were preparing ourselves for what could turn out to be a very tragic night.

Waylan continued to be very sick all night long, but the next morning the doctors discovered that apparently he was allergic to the medication they were using on him. They switched his medicine to another powerful drug that was administered intravenously and Waylan's condition changed almost instantly. It was an answer to our prayers.

Suddenly, my son looked more like the healthy, robust young man that I knew and not this pitiful pale shell of a boy. After five long days in the coronary care unit, we saw Waylan released to a room in the step-down unit where they continued to monitor him closely. It was Christmas Day and we felt this was the best Christmas present in the world. My son, Charles, left his family in Georgia to fly up and be with us, and it was such a blessing to spend that Christmas together with all of my children, even if it was in the hospital.

Waylan was released in another five days and came home where he was confined to the house for the next two months. Because the virus had hit him so hard, it would be a slow recovery for him. The school sent a homebound teacher to our home to teach him so he wouldn't fall behind in his studies. It would be a long two months, but my son was alive and I knew that God had performed another miracle in my life because of prayer.

Following in Muh's Footsteps

God had been so wonderful and faithful to me and I wanted to be of more service to Him, so I became very involved in helping to get our first church building constructed. This church was precious to me. It received its very beginnings through the diligent prayers of seven women who met in my home on a weekly basis to seek God's direction in our lives. The vision for a new church was born through the tearful prayers of these women, right there on my living room floor.

It was now a growing and thriving ministry. It was such a blessing that God would use me, a little nobody from a small town in North Carolina, to help start our church. What became even more special to me was that I later found out that my paternal grandmother, Muh Tippett, was instrumental in starting a new church when she was a young woman. This really inspired me to throw myself into this first building project of the church.

About this time in my life, when I felt so close to the Lord, I had another challenge. Even though I believed that Satan was trying to sidetrack me from my work at the church, I realized how God used

the incident to teach me more about how little we understand of His big picture. My house was set on approximately half an acre and the city was in the process of installing a new sewer system. They had determined that they needed a portion of my property on which to place a pumping station. I received a letter from them outlining their plans and it appeared that they wanted this chunk cut out of my property for their project.

I was so upset over this. They made it sound as though I had no choice and would have to comply. I thought of how indignant it would be to have a sewage pumping station set on my property. All I had ever heard about these things was that they were noisy and smelly. And with the way they were planning to carve up my property, it would render the surrounding land virtually worthless. I contacted the city and told them of my objections and they basically let me know that if I didn't comply, that they would just condemn my property and take it anyway. The monetary settlement they were offering me was not very much in comparison to the damage they would do to the value of the remaining portion of my land. Alone and without a husband for advice on such an issue, I worried about it for several months.

Joseph and Muh Tippett.

My brother Douglas finally convinced me that I was worrying needlessly, as they could condemn it anyway. He also said that no one else would ever want to buy that small piece, and I didn't really need it. I decided that if they wanted the land, they would have to purchase the entire back portion of the property rather than carve it up and make the surrounding part useless and of no value to me. I knew that the battle over the land would be one that I would lose eventually, but I told the city if they didn't agree to fairly compensate me and buy the whole back portion, I would have to hire an attorney and go to court which would hold up the sewer project for perhaps a year or more.

I sent a proposal to the city explaining what I wanted in this deal. I set a price and asked for certain things in the way of landscaping to keep the building from being an eyesore for me. They deliberated on the proposal for a few weeks and finally agreed to my demands. I was never thrilled about losing any piece of my land, but I was thrilled that they met the provisions of my proposal. I knew that the Lord had given me the necessary boldness to stand up to the government and maximize the benefit to me in this whole process.

As it turned out, God had a plan all along. As soon as this was complete, I found myself in need of a new car. The money from the purchase of this land assisted me in buying a new car and I didn't have to dig into my savings or take out a loan to pay for it. I realized once again that my worrying was pointless and that I needed to trust God more for His direction in my life.

Mamie's Reunion

Waylan left home in 1984 to attend Bluefield College, the same college that both of my other children had attended for portions of their education. A few short years later, he met a beautiful young girl at college named Kim and fell in love with her. She was a sweet young woman and I knew that I could not have picked a better mate for my son. They were married in March 1987.

Now I was without any family in my home. For the first time since walking those streets in Wilmington, North Carolina, as a young woman, I was alone. At times it was very, very lonely. My house suddenly seemed huge and empty.

Since Papa's death, my mother had been living alone until she came to the point that she needed more assistance with her care. Some of her children were taking turns keeping her in their homes for a couple of weeks at the time, but the bulk of the responsibility had fallen on my youngest brother, Lloyd, to give her a place to stay with him in Washington, North Carolina.

My son, Charles, was a pilot and had his own airplane. He was preparing to make a trip to see me and I asked him to stop in and pick

Mama up so she could stay with me for a little while. She was excited to have the opportunity to fly with Charles again. At ninety years of age she had taken her very first flight with Charles and was able to see her farm, her family's farms, and a beautiful sunset over Raleigh, North Carolina. It was the thrill of her life, so when I told her Charles was going to come and fly her up to see me, she packed her bags that very day.

Charles brought Mama to see me and while she was visiting had expressed a desire to come live with me permanently. Lloyd and his wife, Mildred, had been very gracious in keeping her in their home, but because of their work schedules Mama was having to stay alone for longer periods than she was comfortable with. There had been some discussion about her going to live in a retirement home so she could get adequate attention. This idea did not appeal to her. She knew that I lived alone and worked from my home. I would be in the house for the majority of the time, so she felt she would be happier being in my home with me watching after her and taking care of her needs. This made me happy because, even though she had many special needs and required a lot of care, I loved her dearly and wanted to make her remaining years as comfortable and as peaceful as possible.

It was rewarding to have so much time to spend with my Mama in those final years. She was a woman of incredible strength and integrity. I wanted to be like her in so many ways. Taking care of her, however, was almost more than I could handle at times. She had survived colon cancer thirty years prior and lived with a colostomy, which required special understanding and care. Her diet had to be carefully administered so as not to upset her stomach. There were times when we would be out somewhere publicly and her stomach would get upset and we would have to stop whatever we were doing and find a rest room to take care of her. She was so sweet and apologetic for "making a mess" and having to impose on someone else to have to clean her up. It was an arduous task, but it was my Mama and I was more than happy to take care of her.

She lived with me for maybe two years or more when the Lord showed me that I had limitations, too. Mama was very hard of hearing and wouldn't always wear her hearing aid, which would require me to speak loudly almost to the point of yelling at her just so she could hear me. Over a period of time I developed a nodule on my vocal chord and was having a difficult time getting my voice to a level that she could hear. It was decided that I must have the nodule surgically removed,

thus putting my voice out of commission completely for a while. Then, following that surgery, I was diagnosed as having glaucoma and laser surgery had to be performed in order to stop its progress. These two situations combined made it necessary for Mama to return to North Carolina to live with my brother. I hated to see her go, but it was now impossible for me to care for her.

After moving back to North Carolina, Mama seemed to be having spells that would almost make her momentarily incoherent. It seemed as though she were having some mini-strokes. She had to be placed in a nursing home because she now required around-the-clock care. After this final move, it was determined that she had developed a brain tumor. We would take trips to see her regularly and it was disheartening to see her go down so quickly. She finally came to the point that she was no longer talking and she just laid in a hospital bed, staring at us.

One of the last times I saw her was when Waylan and Kim, with their little daughter Amy, drove me down to spend some time with her. Amy was almost four years old and cute as a button and loved to sing. We stood in Mama's room and talked with her, although she was

Alfred and Mamie Tippett's fiftieth wedding anniversary.

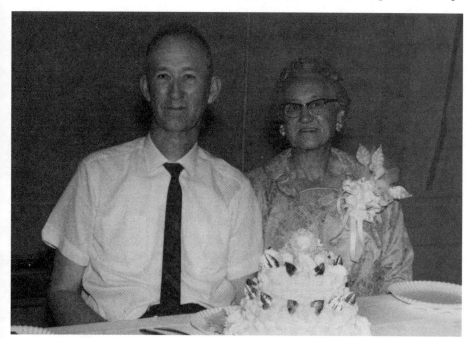

no longer able to respond. Amy decided that she wanted to sing a song for Great-granny and she sat on the bed beside her and sang the sweetest rendition of "Jesus Loves Me," by Anna B. Warner, for Mama. That song was so touching because as Amy sang, Mama's big brown eyes welled up with tears and as soon as Amy finished, Mama spoke the words, "Sing it again, honey." We hadn't heard that voice in over two months and I never heard it again. Amy was glad to sing again for Mama and even sang a few more songs for her. Amy finished her little concert with the traditional ballad, "You Are My Sunshine," and we all had tears in our eyes upon seeing how much this was meaning to Mama. Just a few short days later Mama left this world and entered heaven to see her Savior face-to-face and had a mighty reunion with all her loved ones she had watched go on before her. It was a triumphant day in the life of Mamie Tippett.

God Provides an Unconscious Need

A New Love

*J*ust before Mama's death, God was beginning to reveal more of His plan for my life, although I was unaware of it. It was Mother's Day 1989, and I was very lonesome for my own mother. On the way home from church that night I stopped by McDonald's to get a bite to eat. I was in a bit of a hurry because there was a tornado warning for the area. It was a normal thing for a few friends of mine to gather here after our Sunday night service to eat and to fellowship, but this night not a single person went with me. That made me even more lonesome, but I really needed something to eat.

I don't understand it all, but while sitting there in a booth, I looked up and there directly in front of me sat a little white-haired man in another booth. We looked up at each other about the same time and that was my first awareness of him. I do not know which of us had arrived there first but there was not another person on that side of the restaurant.

Being a friendly person, lonesome, and in a public place, I saw no danger in speaking up, "Do you think we'll get our sandwiches eaten before a tornado arrives?" Our conversation continued with his

mentioning that he had just stopped by following his church service, as I had done. The only difference was that our churches were in opposite directions. He said his name was Odell Davis. We both relayed losing our spouses and how lonely it was. One thing I discovered quickly was that he was a Christian. We finally said our goodnights and went on our separate ways.

The following Sunday night I was with friends at the same McDonald's when I noticed Odell's arrival. We spoke, as he passed our booth to find a seat. The next week I was alone in the same restaurant and rushing to get home. As I arose from my seat, there was Odell in the back of the restaurant attempting to find a booth. I called out for him to come take mine, since I was leaving. He thanked me and asked me to sit back down, if I wasn't in too big of a hurry. I accepted.

We talked and found out more about each other, and he asked me if I was working the following day, which was Memorial Day. I said, "No," and he said, "Neither am I! Would you consider going out to eat with me?" I was a bit shocked, because I really didn't know this man well enough to go out with him and, naturally, I expressed such. After all, that sweet smile and innocent look beneath all that pretty white hair could be a wolf in sheep's clothing. Besides, the most I really knew about this man was that he liked a Big Mac. He asked me to follow him in my car and he would show me where he lived. I guess by this time I was beginning to trust him, so I followed.

He lived about ten minutes from the McDonald's, and I followed him into a nice little neighborhood, neat and clean, with manicured lawns and lots of children playing. He pulled up in front of a cute little white Cape Cod-styled home with black shutters. Everything appeared to be very well maintained, maybe the sign of a perfectionist with a real passion for order.

He climbed out of his truck and walked back to me saying, "Well, this is my place. Would you like to come inside?" Of course, being the nice, southern, genteel lady that I was, I said, "No thank you." But I quickly agreed to the requested rendezvous the next day and said, "So why don't you follow me, so I can show you where I live and you can pick me up tomorrow."

This was the beginning of our friendship and we dated quite often after that. It wasn't too long before Odell confessed that he was falling in love with me and asked me to marry him. At that point in our relationship, I was sure that I was not in love and told him that I could not marry him for that reason. He was very disappointed and it made me

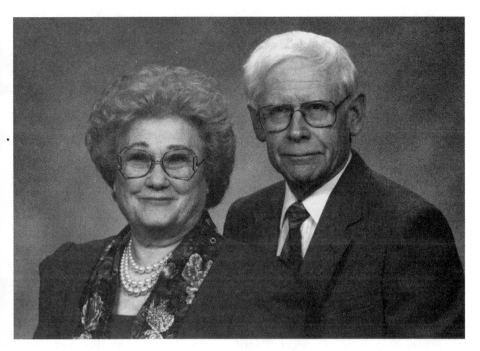

Virginia and Odell's honeymoon picture.

feel terrible because Odell was so wonderful to me. He regularly helped me with my yard work and I thought he deserved a good woman who would feel the same about him.

One day a thought came to me. I had a friend who wanted to meet a fine man and just maybe they would be ideal for each other. Playing Cupid, I suggested this to both and arranged the meeting. They dated a couple of times, but suddenly one evening Odell showed up at my door. I invited him in. He calmly asked me to please never introduce him to anyone else. He went on to say, "If you don't love me enough to marry me, can I just come around here once in a while and be like a brother and help you with your yard work and so forth?" I thought, "What a man!" Little did I realize that my long-term prayer group, the same one that prayed our church into a reality, had been praying for God to send me a fine Christian man! Odell had also been praying for God to send someone into his life that he could help and that would need him.

How marvelous is our Lord? He was doing things for me that I was afraid to ask Him for. Who can know the mind of God? He knows our needs even before we ask Him for anything. My neighbor Nell, who

was also one of my prayer partners, would look across the yard from her house and see me doing all my chores out in the yard alone. She later told me that she prayed for me daily that God would send someone in my life to help me.

I kept seeing Odell and one day I realized that I might be falling in love with this man who was so sweet and persistent. I wanted to be very sure, so I didn't tell him immediately. He was so positive that I was the one that God had sent his way and I was about to believe it also, but I was not going to lead this wonderful man along without being sure.

The day finally came when I knew that I didn't want to let Odell out of my life, so I planned a surprise. Odell never failed to tell me "I love you" whenever we parted, even though I never said it back to him. On his very next visit to my home, and at the moment he said that he loved me, I responded with the long anticipated "I love you, also." His eyes got big as saucers. In fact, I thought he might faint! I didn't think it was really sinking in so I continued on by telling him that we would have to hurry and get married because he was sixty-five and I was sixty-nine and we didn't have that much time left! My children had no idea how quickly things had progressed, so my first duty was to call them that evening to let them know that I was in love with Odell.

Odell and I decided we wanted a quiet family wedding and began planning it for that weekend. I had just informed my children that I was in love. Now I had to tell them I was also getting married two days later. They were all a little shocked and teased me about a shotgun wedding. Nevertheless, they were all elated and agreed to show up.

The plans were to have the wedding take place in my living room. Since my son-in-law, Bob, was a minister, he could perform the ceremony. My son Charles would give me away, Waylan would be Odell's best man, and Verna would be my matron of honor. My niece Kathy, who lived nearby, would play the piano as we entered. What a perfect wedding, and I almost missed the blessing that God had waiting for me. He had sent me the third good husband even if it was at a McDonald's! It is true that God does work in mysterious ways and He has blessed me very much indeed.

27

Odell's Incredible Journey

Odell and I were extremely happy together. Here we were in our golden years and God had enabled us the privilege of having a mate to spend them with. I never thought I would be married again, but that's what I get for thinking! God has always shown me that He takes care of the big decisions for me.

Odell continued to work for a living. He loved his work as an auto body technician and was not ready to retire. He worked long, hard days and could run circles around the younger men who worked in the shop with him. I often worried that he was overdoing it at his age.

Odell was never sick it seemed, but it was about two years into our marriage when he seemed to have a serious problem. He told me that he had a pain in his stomach that had persisted for a few days. He had such a high tolerance for pain that I knew it must be serious for him to complain about it. I took him immediately to an urgent medical care center near our home. The doctor there diagnosed him incorrectly, saying that he had an impacted bowel and that he just needed an enema. Taking the doctor's advice, we went home and that very

same night I had to rush him to the emergency room. Odell was in such pain that he was doubled over and could not stand up straight. The doctors there found that Odell's appendix had ruptured and probably had been for some time. They performed emergency surgery and I was very fearful for my husband. At his age this was certainly a life-threatening situation, but in a week's time and with much prayer he was able to return home and I was sure that he was on his way to recovery.

I was to be greatly disappointed because a few days later Odell became so ill with stomach pain that I had to call 911 to summon an ambulance. We arrived at the hospital again, but it was Saturday night and the hospital was so busy that it seemed like hours before he was admitted.

The following day was Sunday and Odell was left in a room with minimal care. My daughter Verna, my granddaughter Annette, and my son Waylan were with me at the hospital and we noticed that Odell had become almost unresponsive. We wondered if he might be going into a coma or something. Verna said that no one had even taken his temperature all morning so we called a nurse to come in and check him. The nurse discovered that his temperature was 105 degrees and by now he was starting to shake uncontrollably. No longer unresponsive, he was beginning to cry out in pain. We knew something terrible was happening to him and we were even more upset that the staff on duty seemed to be oblivious to his condition.

Verna had some medical background and Annette was in college studying to be a nurse so together they were bold enough to go to the people in charge and let them know that they were falling down on the job. Verna told them that anyone who had a temperature of 105 degrees, having convulsions, and in as much pain as he was certainly needed to be placed in intensive care. After seeing how upset we were, they began to make arrangements to get Odell to the ICU. By this time he was so ill it appeared to me that he surely was going to die. After the move, he hovered between life and death. Each day they performed tests and each day they said that he was too ill to survive surgery. He was in the ICU for three days and it was Wednesday when they decided they would have to perform surgery because he would not survive at all if they didn't.

Odell's operation indicated that a part of his colon, at the point of the previous appendix surgery, had twisted around some scar tissue that had formed, thus completely blocking his bowels. They

Virginia and Odell at Virginia's eightieth birthday party.

had to remove about a foot of dead tissue that resulted from the lack of blood flow.

I will always remember the days following this surgery as an unending nightmare. Odell went into a coma and was placed on a respirator to assist his breathing. He began to swell and turn yellow from jaundice. His bed monitored his weight and he went from an average weight of 150 pounds to 224 pounds. His hands were so swollen that his fingers could not touch one another. He looked like some sort of monster to us.

Because of the swelling they had to staple and restaple his incision to keep it closed because it kept tearing open. With all of this happening to Odell, he still ended up with a staph infection as well. The word went out to many churches and we had hundreds of people praying for my husband, especially my friends who knew that I had lost two husbands previously.

Things didn't look good for us, yet Odell's doctors were working hard to keep him alive. Verna stayed with me in the waiting room day and night. Waylan and Charles stayed with us as often as their jobs permitted. Every time they would allow us to see Odell, we would go

in and talk to him. Even though he was unconscious we would tell him how much we loved and needed him to get well. I believed in my heart that he could hear us, so we would do this each time we were allowed to visit him.

About twenty days after Odell's admission to the hospital, the doctors came to me and prepared me for the worst. One of them told me that I would have to make a decision about Odell. He said, "I have never seen anyone live who is this ill." His body was in septic shock, and one organ after another would shut down.

Another specialist was called in to monitor each major organ and work to revive its function, but as one would rebound another would start to fail. It seemed as though all efforts were now exhausted. The doctor told us that we had better contact our minister and prepare for his funeral. Unless you've been there you cannot know what it's like to think God is going to take your third husband away from you. I knew my faith had always been strong but this was almost too much to bear. I felt as though God had forgotten to take care of me.

I began to call friends and relatives to come to the hospital, and as I cried I began to plan Odell's funeral. George Pierce, my former pastor, along with his sweet wife, Helen, stayed close by me during these days of trauma and I asked him to officiate the service. My son-in-law, Bob, would also be a part of it. I called Charles, requesting that he return from North Carolina and to be prepared to stay for the funeral. It is hard to yield your will to God's will when it comes to the death of a loved one, but I knew it was the right thing to do. The doctors told me I would also have to make a decision about continuing life support.

I believe it was at that time that God moved in and showed me that He had not forgotten me. A miraculous thing happened. Odell showed signs of improvement and actually started to breathe a little on his own. We didn't have to make a decision about the life support, for God was the one who gave His life support.

During the days ahead, Odell continued to improve and was finally moved to a step-down unit for the less ill patients. He was not talking yet and still partially comatose and they monitored him closely. He also was being fed through a tube in his nose and into his stomach. He was still a very sick man so I remained close by him as did Verna. One morning she and I arrived at the hospital about 8:00 A.M. and as we approached Odell's bed we saw that he was vomiting the liquid food and was aspirating it all. Again, no one was close by so we tried

to lift his head but found that his hands were tied to the bed so it was difficult to help him. Verna screamed for the nurse and she came. However, they never did anything else for him until late that afternoon when I insisted that she call his doctor. His breathing was a gurgling sound as though his head was under water.

I thought "Lord you have brought me to this point of believing that Odell was going to recover, please help me for I don't believe that I can stand any more." At the end of that day Odell was still alive, then suddenly a doctor appeared and called for a nurse to get him back into ICU. She said that they did not have any room for him. He very firmly told the nurse to "find a place for him anyway, and immediately!" Soon after this we found out that he had developed chemical pneumonia from the aspiration.

My hope for my husband's life was like a thermometer, one day it was high and the next day it was low. It seemed as though I was suspended in mid-air. The nurses in the ICU by this time had all begun to know us very well and all of them became very concerned. He was in the ICU this time about ten days and began getting somewhat better.

They wanted to transfer him to the step-down unit again and I protested because of what happened the first time. I had reached a point of threatening to take him out of the hospital and putting him in another facility. They told me that they would place him directly across from the nurses' station and assured me that they would watch him more closely this time. I agreed to this.

He was in the hospital a total of forty-four days the last time, almost all of it in a coma. He even had to have therapy to start walking again. God did perform a miracle on Odell for he was able to return home. His doctor said to me one day, "You people really believe in prayer don't you?" I replied, "I sure do, for I know what God has helped me through at different times of my life." He did things that man can not do and there's no explanation except for the fact that God did them.

Verna stayed by me for five weeks away from her husband and children and it meant so much to have close family ties. She was a great comfort when I would get very low in spirit. Even then, I really did know that God would never leave me nor forsake me. I believe that when someone is very, very ill that the family should talk to that person as though they know every word that you're saying, because I believe that they do hear you. Let them know that you love them and want them to get well because you need them.

Not only did my husband recover and return home, but he also returned to work and continues his hard work to this day. At the age of seventy-seven, he works a forty-hour week and is one of the best auto body technicians in the Tidewater, Virginia, area.

28

New Trials

SEVENTY-NINE-YEAR-OLD COMPUTER STUDENT

Odell's operation was in 1992, and for the next eight years we were blessed with few major challenges other than some minor sicknesses and my carpal tunnel operation. The year following Odell's illness saw the death of my oldest brother, Elbert. Even though he was seventy-nine years old, he was in good health and we were shocked at his passing. God was good, though, and apparently took Elbert peacefully and quickly. Kathryn, his wife, had seen him through her kitchen window working in his yard and only minutes later he was with the Lord. My brother Douglas lived until 1997 when he had a stroke and he went on to heaven. Finally, my sweet sister-in-law Kathryn joined them in glory in February 2000.

Like many others, we felt blessed to be alive and watched the new millennium come in. In November 2000, I entered the hospital to become what some have called a "seventy-nine-year-old bionic woman." I decided to have a long-postponed hip replacement, giving me a titanium ball with a plastic socket. Yes, I had put it off for about two years, partly from fear and apprehension. Knowing that I would be incapacitated for a while following the surgery, it worried me somewhat. I am

not the kind of person who takes to confinement very well, and I was worried about seeing only the inside of my house for six weeks.

Odell was fearful for my health as well, but my children, especially Charles, continuously encouraged me to have the procedure done to improve my quality of life. At times I had considerable pain from the bad hip. Everyone seemed to feel that this rather routine surgery was nothing compared to some of the other challenges I had faced.

The Lord blessed once again and I discovered that I had worried needlessly. Turning it over to Him, I was up and about the morning following surgery and I was walking! Light therapy began immediately and after a week or so, I felt as good as new. I did so well that continuing therapy was not necessary. We managed to enjoy a wonderful family Thanksgiving with all my children, almost all my grandchildren, and even a great-grandchild in my own home. It helped to convince everyone to come home, of course, because I was less mobile than my family.

I felt led by the Lord for some time to write a book of encouragement drawing from my own life's experiences. I have always felt the Lord gave me a gift to encourage others. This need to write it down just would not go away. Following my hip replacement, and being shut in for a while, it seemed an appropriate time to begin to gather my thoughts. This was one more instance in my life when there were rewards I had not considered nor visualized.

It all began with a yellow legal pad. Before I knew it, there were more than one hundred pages, some back and front with scribbles and notes in the margins. At times, I read portions to my family and friends and we would sometimes laugh and cry together. Once again there were many who felt it should be published in an effort to encourage others. This just seemed to fall right in line with what I felt the Lord had always led me to do.

One evening when my son Charles called me long distance, I was so excited about what I had written so far that I held him captive on the phone, while I read for better than forty-five minutes! We were both so excited. He had continuously tried to convince me that the material had to go into a computer or no one would be willing to review, edit, or publish it. I was always apprehensive about that because my computer experience was very limited. It began when Waylan brought a computer in and set it up in my house immediately following my surgery. It was one that his eleven-year-old son, Seth, was using at home. Seth thought it would be good for his Granny to

have it for a while and learn to play games on it. Well, I really wasn't interested in playing his games, but I managed to get a lot of entertainment out of the simple card games that were installed.

The idea of having my own computer was scary for a couple of reasons. One, I really didn't know what I was doing and two, I had never even learned to type! We battled over this for several months and Charles finally won. He became the driving force to bring his mother into the twenty-first century with her own computer.

He helped me invest in a computer and set it up in my guest bedroom where I could concentrate and try to finish my book. Meanwhile the Lord led me to title my book, *The First Eighty Years*. I know that my first eighty years is only the beginning of what the Lord has in store for me in eternity, and I felt this catchy title would also generate some interest in the bookstore.

Now, the problem was how I would get all those pages in chronological order into this new machine. Charles helped me decide that we would invest in something called Voice Recognition Software. It proved to be an amazing tool. It allowed me to dictate my entire book into the computer and enhance it by adding new material, all while

Virginia at her computer.

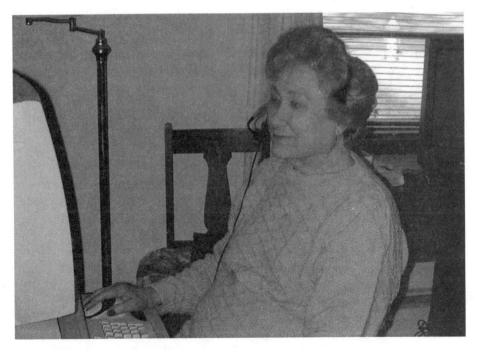

wearing a headset and microphone. I seldom had to even touch the keyboard. That may all sound easy, but it was not easy for a lady pushing eighty years of age.

We both had to learn to use the software, and as he constantly reminded me the computer is a "dumb animal." The computer had to learn my country girl lingo as well as my southern accent.

The early days were tough and full of frustration. There were times when I would call Charles in North Carolina or Waylan at his office and advise them that I was going to throw the computer out of the window and I would write my book some other way. Sometimes I would get something fouled up and call Waylan to drive the two miles from his house to fix it for me. He would walk in and click on a couple of things and walk back out of the door. That almost made me angrier than messing up did to begin with. "Smarty!" I would think. At least he could have acted like it was something a little more difficult to fix.

The powerful listening software would sometimes hear things that I didn't want it to hear. It once saved a chapter file called "Go to the top of the page" because of the verbal command I had given it. It listens to everything you say and you must be careful to say, "Mic off" or the microphone stays on and continues recording.

We all had a tremendous laugh one day when a couple of dictated lines typed out in a language other than English. From time to time I would click the wrong button or say the wrong command and the computer would start reading my book back to me in an unknown female's voice. Other times I would command the computer to do something specific (or so I thought), and it would take off and do something completely different as if it were possessed with a mind of its own.

Another day, Waylan and I had a hearty laugh over the tutorial lessons that came with my software. The tutorial is set up to make learning the program fun. It starts out in a little restaurant with a waitress named Jane who walks you through the various functions. As she tells you certain things, she expects you to talk back, so that she knows you are with her. Well, the software had some sort of glitch in it and failed to work properly. I would get part of the way through the tutorial and suddenly Jane could no longer hear me. She would start saying things like, "Hello?" and "Are you there?" Of course I was there. I kept telling her I was there. She almost sent me over the edge when she made a smart gesture by tapping on the screen and asking me if I went to get a cup of coffee. My coffee pot wasn't even on. Waylan had to stop me and remind me that I was having a fight with an imaginary woman

in the computer. Well, she seemed real enough! It's a shame for a computer software company to tease an old lady like that.

Charles told me to just get the book into the computer and forget the grammar, spelling, and event sequence. He helped by setting up the word processor files to arrange the material in an orderly fashion, editing and formatting the final text, and the photo scanning. Waylan has considerable creative talent and has helped by going through the book chapter by chapter, editing and enhancing the material. We believe he gave the book character. My daughter Verna was very good at helping me to remember dates and sequence of events. Then all three of my children would recall other events in my life that should be included in the final project, some of which had completely escaped my memory. I felt so blessed to have all of my children actively helping me with my book. It became a family project.

One thing about my computer that I had to learn the hard way was to save my work as I went along. Charles had taught me what he called minimal computer skills to keep it simple for me, but saving my work and the files was a very important aspect that I didn't catch on to in the beginning. Once I lost three days of work and we have not found it to this day. I cried for an hour. We tried to search for it. Waylan came to the house and searched for it with no luck. Charles helped by phone and tried to find it, but he finally conceded saying, "Mom, it happens to all of us." With that we gave up the search and rewrote three days worth of work. Of course I learned from it and today I view the computer as just another of the challenges in my life that, with God's help, I have been able to tackle with moderate success.

I have also learned about surfing the Internet. This was necessary because I had to research certain things for the book while looking to secure a good publisher. Learning to e-mail was also a must and I admit that I have enjoyed keeping up with my children, grandchildren, and other family and friends using electronic mail. We've sent numerous files and pictures to each other by way of e-mail.

All of these were big challenges for me, but I am confident today that the Lord put these challenges in my life for a purpose. Consequently, I try to encourage my friends to be open and to pray about trying new and difficult tasks. I don't believe that just because you live to be a ripe old age you should sit around and cease to function. God has work for us all to do, even in our twilight years, and He will give the necessary skills to accomplish His will, if we trust Him. By allowing Him to use us, we will all be blessed by His work in our lives.

Matthew 17:20 says: "And Jesus said unto them, Because of your unbelief: for verily I say unto you, If ye have faith as a grain of mustard seed, ye shall say unto this mountain, Remove hence to yonder place; and it shall remove; and nothing shall be impossible unto you."

John 16:24 says: "Hitherto have ye asked nothing in my name: ask, and ye shall receive, that your joy may be full."

We set up my computer on August 23, 2001, and by the end of November, the book was almost completely in the computer. We added a few more chapters after that and had a finished work. Everyone told me that I learned the computer quickly. For a country girl who had only an eleventh-grade high school diploma, that I knew once again that the Lord just blessed me beyond my wildest dreams.

An Eighty-Year-Old "Coming Out" Party

A s I approached the last chapter of this book on November 17, 2001, I had the most amazing experience. My family gave me one of the greatest and nicest surprises of my life. Unknown to me, they went through journals, address books, and everything they could find to get names of people whom they thought had meant a great deal to me in my life, including my former clients in the hairdressing business.

On the afternoon before my eightieth birthday, Waylan asked me to go with him to our church to see his daughter, Amy, as she participated in a youth program. Of course, being the proud grandmother of this beautiful sweet young lady, I naturally said yes. There was to be a portion of the event in which she would be paying some kind of tribute to her ole' Grandma. How could I turn that down?

I have always tried to encourage my children and grandchildren to be active in their churches. Waylan plays the piano and his wife Kim plays the keyboard at our church. Their children, Amy and Seth, are active in the youth department while their four-year-old, Trevor, keeps the childrens' workers busy. It was not unusual in any way for

Eightieth birthday party table.

us to go to some mid-day function at the church because of the family's involvement there.

Kim had gone ahead to the church earlier with Amy. Waylan said he would come by and pick Odell and me up in his car so we wouldn't have to drive ourselves. He led me to believe we were running late and he was fearful that I was going to miss Amy's presentation. A couple of things happened that might have raised my suspicions on the way to the church (like Waylan driving below the speed limit when we were running late because he doesn't drive below the speed limit when he's on time). However, I just passed it off as Waylan being his own unpredictable self.

When we arrived at our fellowship hall, Waylan opened the door for me to go in and I looked into a darkened, beautifully decorated room. It was full of people and had a thirty-foot-long table in the center filled with food, decorations, and flowers. At first, it didn't register that it was for me because I was still thinking that this could be part of the youth program which, supposedly, had already started and that there were to be refreshments afterwards.

It dawned on me that something was fishy when my eyes focused on a friend who lives on Roanoke Island, North Carolina. I thought

to myself, "Why would Nora Drinkwater be here?" I went through the door and about 150 people immediately stood up and shouted, "Surprise!" I was in shock! Everyone started singing "Happy Birthday" and as I tearfully looked around the room, I saw so many faces of people that I loved dearly, some of whom I hadn't seen in many years.

As soon as the singing stopped, a large unkempt woman wearing thick-lens eyeglasses and disheveled hair came running toward me calling out, "Virginia, I'm one of your long-lost relatives!" As she drew near to me I saw the worst looking set of teeth poking out from between her lips that I had ever seen! I knew it had to be some kind of joke.

She loudly announced that she was one of Alfred and Mamie Tippett's children who had been left behind at an orphanage because she was so ugly. She continued cracking jokes, but as she came up beside me I thought to myself, "Hmmm, I'm going to find out who you are!" Yet with all of that garb on, how could I do that? About that time she pulled an accordion out of a suitcase and started playing "Happy Birthday." That gave me a clue. I looked into the two small

Virginia meets her "lost relative."

Virginia and Kathy at the eightieth birthday party.

Cake on the table.

circles of her thick glasses that allowed her to see through and I knew those eyes. She has very beautiful eyes.

Now just one more clue and I knew I would be able to identify this so-called long-lost relative. I could see a few strands of blond hair protruding from under her baseball cap. I said, "Kathy! I know those eyes!" She exclaimed in an awful southern accent, "You know Kathy isn't as purty as I am!" I said, "Kathy, you look just like you have always looked!" She moaned loudly and said, "Oh! You're really gonna hurt my feelings."

Lloyd and Mildred Tippett.

Waylan and Kim Goddin.

Virginia's grandchildren. Front row, left to right: Seth Goddin, Jennifer Snow, and Amy Goddin. Middle row: Jason Reese, Brian Snow, and Annette Reese. Back row: Kenny Reese and Robbie Reese.

Of course, that was not true. My niece Kathy is, in fact, an extraordinarily beautiful woman. She is the daughter of my oldest brother, Elbert. Remember, Elbert and Kathryn had been there for me when Claude was born and Charlie was dying. They continued to send us money for many months until I was on my feet. They were there in Rhode Island when I needed wise guidance upon leaving New York for Virginia. And after we settled in the Tidewater area, they moved to Norfolk where Elbert was stationed in the Navy, always providing family support.

Their daughter, Kathy, has always been precious to me. She is so sweet and she is also most talented. Kathy and her husband Doug had traveled from Florence, South Carolina, where they are involved in the Lord's work. There, she plays the piano beautifully for her church while Doug is the minister of music.

I looked around and all I could see was people. I had family and friends from at least three states. Kim had done most of the decorating and provided much of the food, while many others assisted her. The food and fellowship were wonderful. There was a beautiful cake made of mocha chocolate and macadamia nut

Virginia's youngest grandchild, Trevor Goddin.

Virginia's great-grandchildren, left to right: Gillian Shelton, Jacob Shelton, and Joshua Reese.

filling. It had another cake on top in the shape of a book with this book's title and author on the top and binding. The event doubled as my book's coming out party.

The program they planned was precious. They had Odell and me sit on the stage in two over-stuffed gold chairs. Four men, Charles, Waylan, Kathy's husband Doug, and my brother Lloyd got together after arriving and practiced so they could sing to me as a barbershop quartet. They all have beautiful voices and had a terrific blend. A dear Christian friend and professional singer, Delores Forehand, sang a favorite song of mine, "Down From His Glory," by William E. Booth-Clibborn. Different people came, one by one, to the microphone on the stage and shared special memories about me that they felt appropriate.

My children did some joking and gave some serious compliments as well. Some people thanked me publicly for my love and encouragement in their lives. Others thanked me for helping them in times of trouble and turmoil by listening and praying for them. It was a humbling experience to have people stand and tell me how I had affected their lives. The greatest compliment of all was that I had somehow helped someone else live for, and draw closer to, the Lord. It is too bad that we don't realize earlier in life how important our lives and our testimonies are to other human beings.

The roasting was a wonderful combination of laughter and crying. Finally, with Waylan on the piano and Kim on the keyboard, they concluded the program with the crowd singing four of my favorite traditional hymns. It was a wonderful feeling, one that I have never experienced before. It made me realize what Papa meant when he used to tell us, "Give me my flowers, while I live." Now it does make a little more sense to do it that way, rather than waiting for a loved ones' funeral.

Epilogue

I want to remind my readers that I have always been led of the Lord to encourage others and give them something to help them as they journey through life. I believe He continues to use me this way. I love people because the Lord loved me first and commands us to love others.

> *This is my commandment, That ye love one another, as I have loved you.*
>
> John 15:12

I do not want sympathy for any of the tribulations and trials that I have had in my eighty years. Many people have had similar difficulties and some have had far greater tribulations than mine. But I want to remind you that the ending of my story is happy, just as it was in the Book of Job.

> *These things I have spoken unto you, that in me ye might have peace. In the world ye shall have tribulation: but be of good cheer; I have overcome the world.*
>
> John 16:33

Rather, I want anyone who reads my story to see how the Lord has taught me and helped me to grow through my trials; thus He has brought me closer to Him.

I thank God for all His goodness and what He has done for me all these years. My prayer today is that I can help others experience God's

blessings as I have. I want to leave a legacy that my life has been an inspiration to all who knew me.

To those who have never experienced the wonderful love and saving grace of Jesus Christ, I want to tell you that you can know Him as I do in a personal way by asking Him to forgive you of your sins and come into your heart. The only way to heaven is through a personal relationship with Jesus, who said,

> *I am the Way, the Truth, and the Life; no man cometh unto the Father, but by Me.*
>
> <div align="right">John 14:6</div>

God's simple plan for salvation concludes this book.

If you've been blessed or encouraged by my story, please tell others in an attempt to reach the greatest number of lives.

God's Simple Plan
For Salvation

For all have sinned, and come short of the glory of God.
Romans 3:23
🙢

For God so loved the world, that he gave his only begotten Son,
that whosoever believeth in him should not perish,
but have everlasting life.
John 3:16
🙢

For the wages of sin is death; but the gift of God is eternal life
through Jesus Christ our Lord.
Romans 6:23
🙢

That if thou shalt confess with thy mouth the Lord Jesus,
and shalt believe in thine heart that God hath raised him from the
dead, thou shalt be saved. For with the heart man believeth unto
righteousness; and with the mouth confession is made unto salvation.
Romans 10:9, 10
🙢

About the Author

Virginia Davis was born on a farm in Zebulon, North Carolina, to Alfred and Mamie Tippett. The fourth of six children, she was raised in a loving Christian home. After graduating from Corinth Holder High School in Johnston County, North Carolina, she moved to Greensboro and later to Wilmington to work in the retail shoe business during World War II. She received a diploma from the Vogue School of Beauty Culture in New York, New York, and worked as a professional hairstylist until her retirement.

Virginia Davis currently resides in Chesapeake, Virginia, with her husband, Odell. She has three children, nine grandchildren, and three great-grandchildren. She is a member of Nansemond River Baptist Church.